D0461749

EXTREME design

EXtreme Design

EXTREME

EXTREME

EXTREME DESIGN
SPENCER DRATE
+
JÜTKA SALAVETZ
FORWARD BY SCOTT CLUM

EXTREME

HOW
DESIGN
BOOKS
CINCINNATI, OHIO
www.howdesign.com

ACKNOWLEDGMENTS

To David Lewis, Clare Warmke, Linda Hwang, Lynn Haller and everybody at HOW Design Books who believed in this vision. To Ariel and Justin for their guiding light. To Scott Clum, Sean Mosher-Smith for their invaluable contribution and to all the talented EXTREME designers who contributed to this book.

Other fine HOW Design Books are available from your local bookstore, art supply store or direct from the publisher. Visit our Web site at www.howdesign.com for information on more resources for graphic designers.

05 04 03 02 01 5 4 3 2 1

Library of Congress Cataloging-in-Publication Data
Drate, Spencer.
 Extreme design / Spencer Drate and Jütka Salavetz ; forward by Scott Clum.
 p. cm.
 Includes index.
 ISBN 1-58180-093-2 (hc)
 1. Commercial art. 2. Graphic arts--History--20th century. I. Salavetz, Jütka. II. Title.

NC998.4 .D73 2001
741.6'09'04--dc21 2001024828

Edited by Clare Warmke
Editorial Assistance by Deborah Gonzalez
Production by Emily Gross
Interior designed by Jütka Salavetz + Spencer Drate, with Sandy Kent
Cover designed by Scott Clum

The permissions on page 160 constitute an extension of this copyright page.

This book is dedicated to our parents who gave us the wisdom to be the best at whatever we endeavor to do.

We also dedicate this book to Justin + Ariel; the strength they give us to see the EXTREME beauty and magic in life.

TABLE OF CONTENTS

EXTREME DESIGN

Doing a cover for Extreme Design brought all my usual design perspectives to a dead halt. How does one make a cover "extreme" enough for a book titled Extreme Design? I decided early on that I was not going to push myself to create the most extreme of covers; I'm not sure that I could. Instead, I chose to focus on the thought process and let the depth communicate extreme.

The most extreme part of design, I believe, is the thought process—the intangible part of design that generates the best ideas and most provocative images, but is often impossible to see. In designing this book's cover, I tried to put my thought processes of design in the forefront.

The images on the cover are an accurate representation of my thoughts. To me, this is the extreme part: the thought process. We all follow our own processes for design. The thought process is the mental visualization that becomes the constant sketch. The design itself may not always be extreme, but the thought process of the designer always is. I can honestly say that the thought process is the most extreme part of my approach toward design.

I employ both fine art and design disciplines in my approaches. Each of these leads me to different ways of making a decision.

But what is extreme? One of the problems with defining this concept is that it's different for each of us. It seems the life of design has become shorter. So is it the life of design that's extreme? Maybe, but the life of the thought process is infinite. This could very well be the high point of design—pure thought. We rarely see the final design encompassing the many phases of thought. A lot of design looks so compressed. Of course, it's hard to see the entire process, although some design shows these anxieties of thought very well (while other design barely has a presence).

A lot of people have said design isn't anything without content. I agree with this statement. Content is thought.

It's hard to say if any of the mainstream design out there can be considered extreme. So much of it rarely reflects process and the extremes we all go through to get there. Design is about change, interpretation and content, and sometimes style. But change is design's biggest motivator. Right now, the new typeface is the Internet. Its presence is overpowering for the moment, and that kind of influence can be extreme for the design community. It is change.

I can say with assurance that the people in this book are about change. They are extreme in process and idea. Just the fact that the art they produce brings about change is extreme. The designers in this book have given us a peek into their thoughts by putting their finalized ideas on these pages. These designers have shown us what is most important about being creative and pushing art to the edge: thought and process, overall change. Extreme Design.

Manabu Inada has been the art director at MTV interactive since 1994. The MTVi Group is the world's leading online music entertainment company, with twenty-two Web site destinations around the world, including MTV.com, VH1.com and SonicNet.com. At MTV.com, Inada built the entire Web site from scratch with a team of talented Web technicians. His responsibilities at MTV.com include creative research, development and implementing overall graphic design and branding. Inada won the prestigious AIGA Communication Graphics Award in 1996. His design work has been, and currently is shown, on several exhibitions in the United States and in Japan, such as Motion Graphics, MTV Graphics, Young Guns and the Art Directors Club at New York. Currently, he is producing an international site on MTV.com.

Private Work
Designer: Manabu Inada
Client: Self
Concept: "PC HAKAI is my private design. 'Hakai' means 'crash' in Japanese. It's about a computer crash."

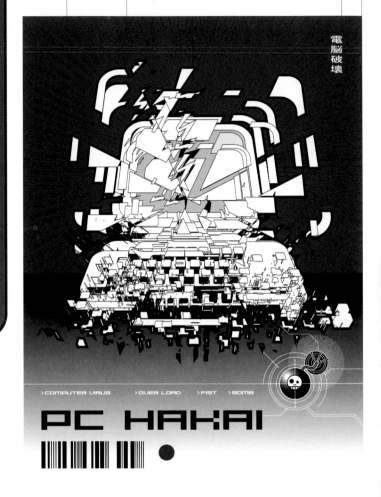

電脳破壊

>COMPUTER VIRUS >OVER LOAD >FIST >BOMB

PC HAKAI

MTV.com
Designer: Manabu Inada
Client: MTV.com
Concept: "When I designed this, I had just come back from a trip to Barcelona, Spain. I got my inspiration from the Gothic architecture there."

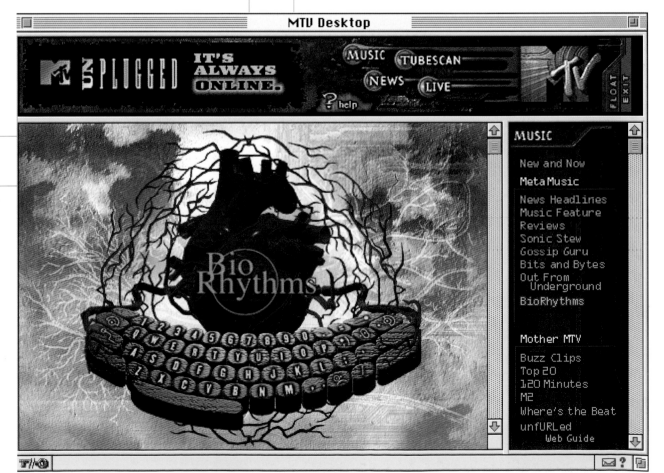

MTV Desktop

MTV UNPLUGGED IT'S ALWAYS ONLINE. MUSIC TUBESCAN NEWS LIVE MTV

? help

FLOAT EXIT

Bio Rhythms

MUSIC

New and Now
MetaMusic
News Headlines
Music Feature
Reviews
Sonic Stew
Gossip Guru
Bits and Bytes
Out From Underground
BioRhythms

Mother MTV

Buzz Clips
Top 20
120 Minutes
M2
Where's the Beat
unfURLed
 Web Guide

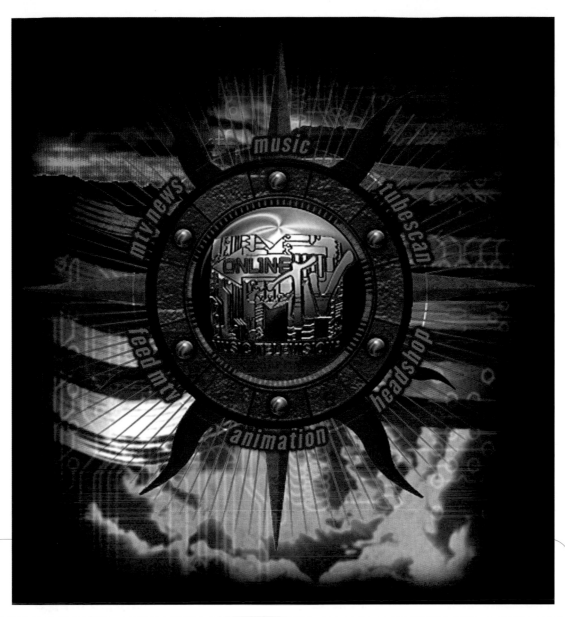

MTV Interactive
Designer: Manabu Inada
Client: MTV.com
Concept: Future primitive. Digital tribal.

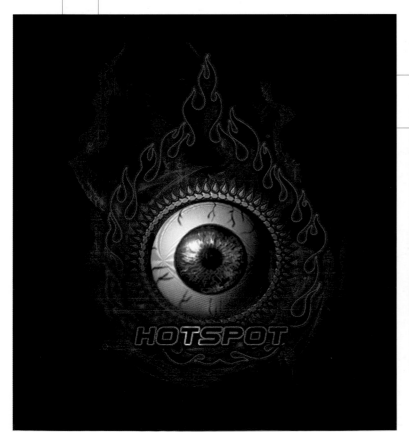

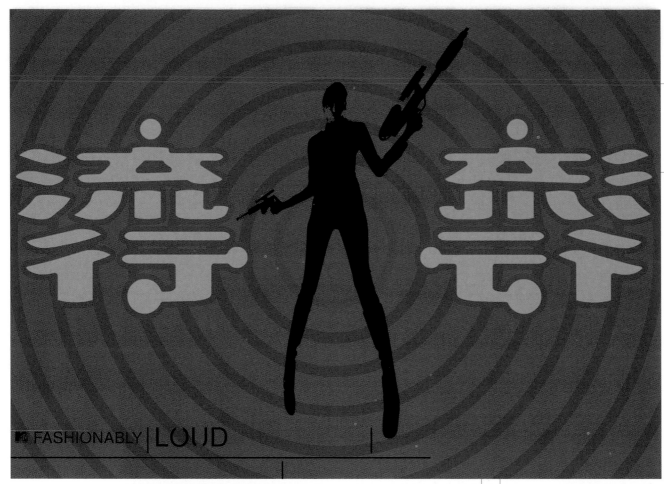

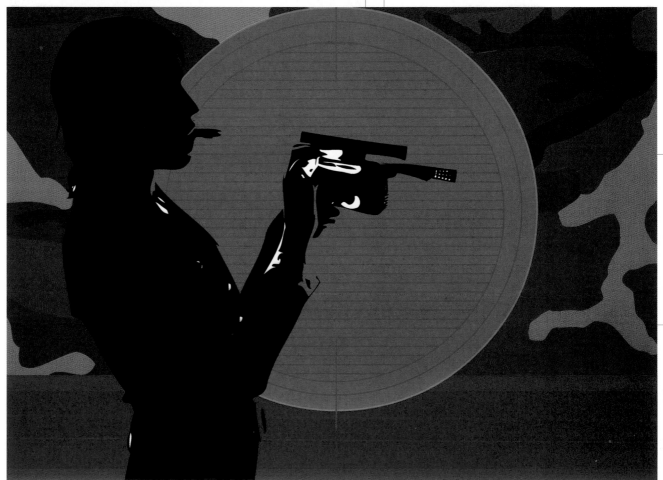

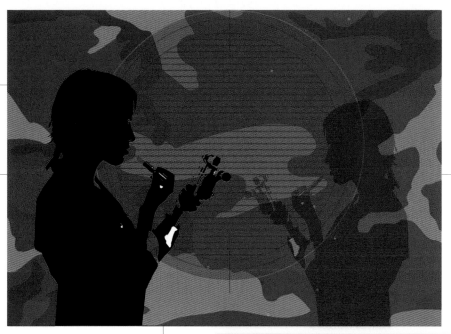

Fashionably Loud
Designer: Manabu Inada
Client: MTV.com
Concept: Secret fashion agent. "Its like a movie trailer-style action sequence. I used an actual model to get a realistic silhouette."

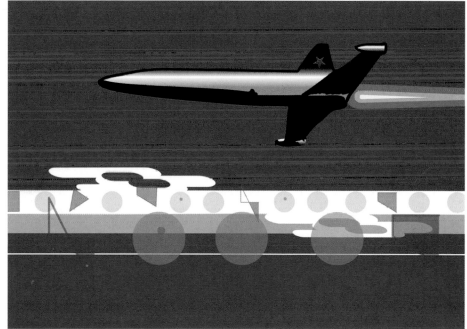

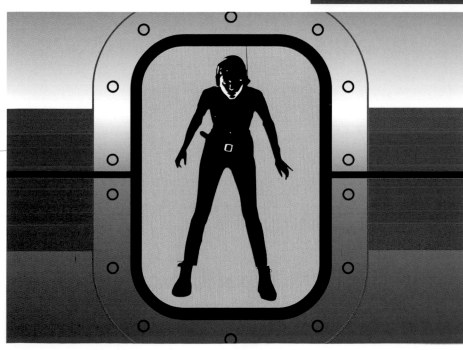

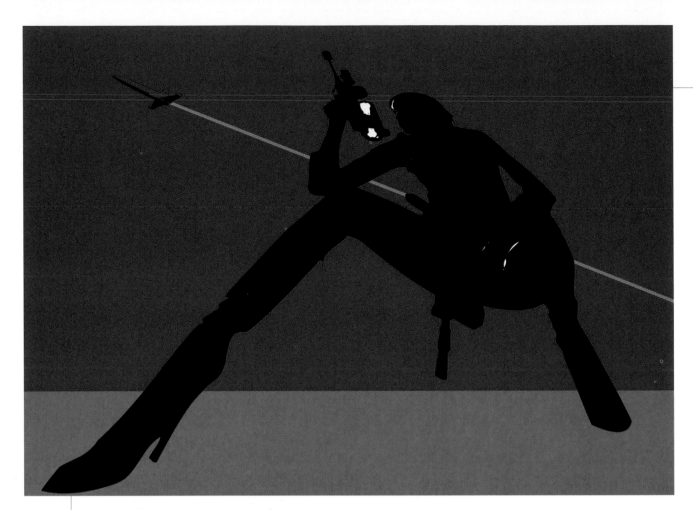

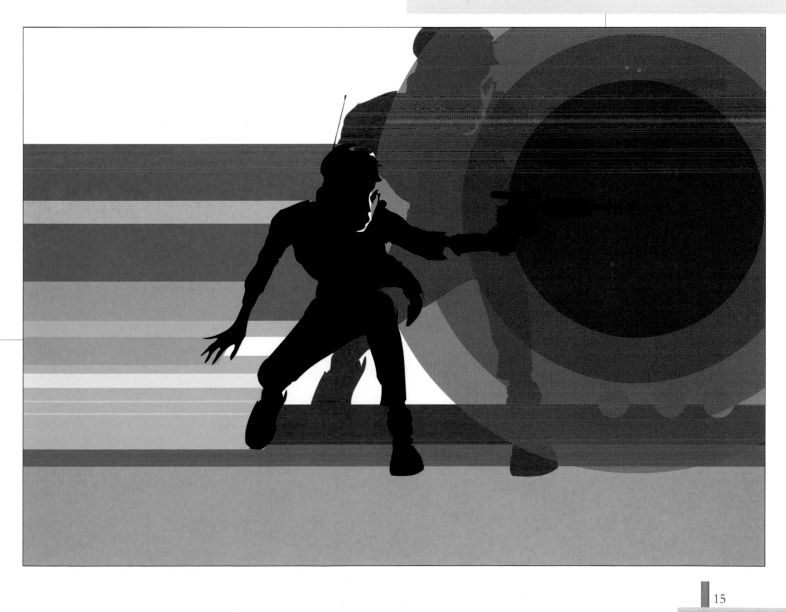

Automatic of London was formed during the postgraduate visual communication course at The Royal College of Art in the summer of 1995. While exploring diverse visual directions on the course, it was the artists' desire to explore the spaces in between their work and the ideas behind the surface—both on a cultural and human level—that pushed them toward forming their own studio.

Automatic is a creative studio embracing design for print, digital and spatial media. They continue to push the belief that projects should be a collaboration with the client, encouraging dialog and growing ideas to form communication that engages the eye and the mind. Each project is approached equally, each solution a natural outcome of ongoing dialog and a desire to make every project unique.

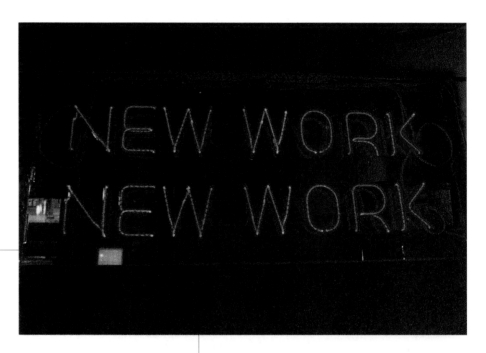

New Work New Work
Designers: Automatic, Toby Haynes
Client: Kingston University
Concept: "Working with Toby, a student who came up with the title 'New Work New Work' for the upcoming degree show, we created a Broadway-influenced neon light to be hung in the exhibition space," explain Ben Tibbs and Martin Carty of Automatic. "Photographs of the neon from the front, from behind and of its working cables and plugs were the main images on the poster and catalog cover. The repeat pattern of asterisks on the catalog end papers mimics the security pattern used on the university pay slips."

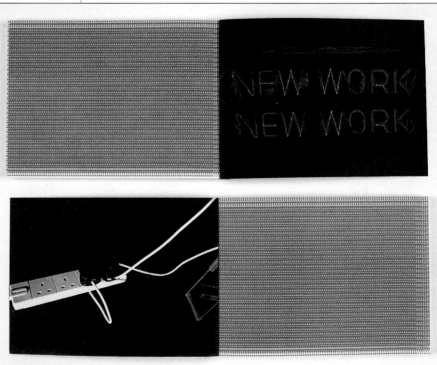

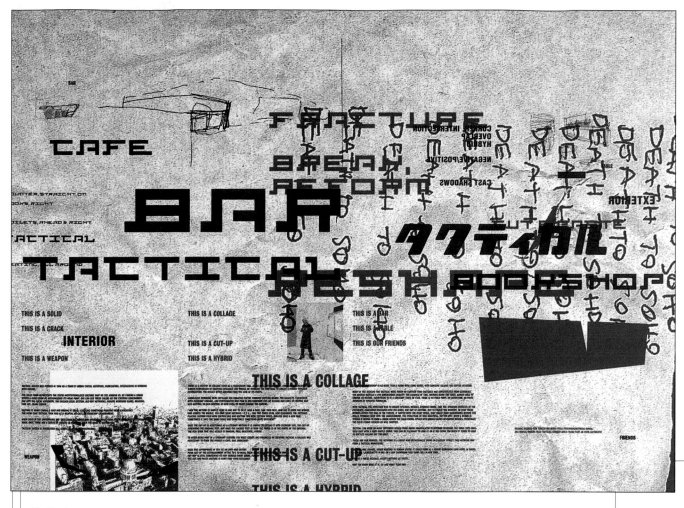

Tactical
Designer: Automatic
Client: Tactical/meeting and performing space for artists
Concept: "Picking up on the team's strong deconstructional philosophies, the book uses and disregards the way that folding naturally interleaves the front and back of a flat sheet and flips the reading direction of the pages. The final form and order of the book was not apparent until just before going to print."

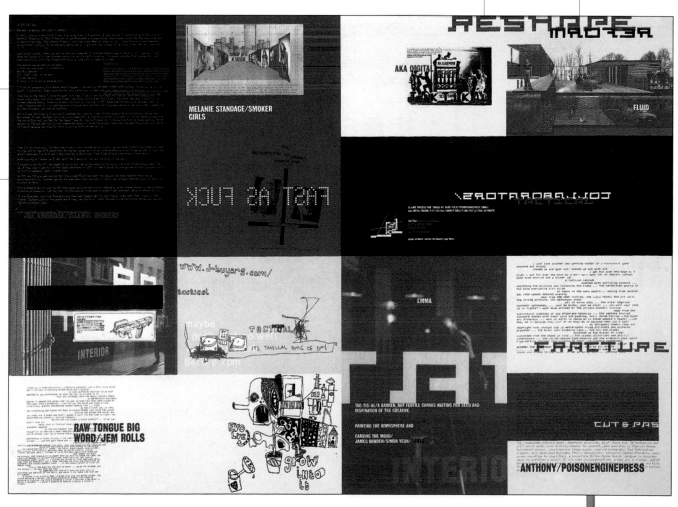

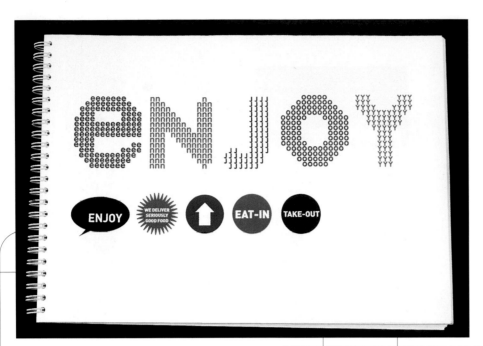

Coffee Shop Brand Concepts Book
Designer: Automatic
Client: BDG McColl/architectural and design consultancy
Concept: "Asked to work on the branding for a new chain of coffee shops, we explored the vocal, spoken feel of the possible brand names 'Prago' and 'Enjoy' with words and phrases used to create a dialog between the shop and the customer. These words were set into the concrete floors, recessed into walls, hidden in the bottom of coffee cups...."

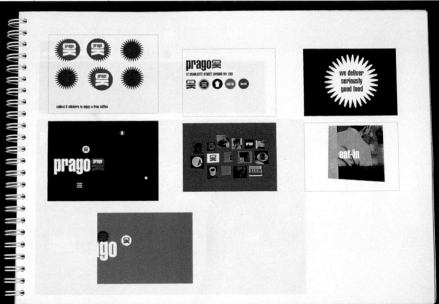

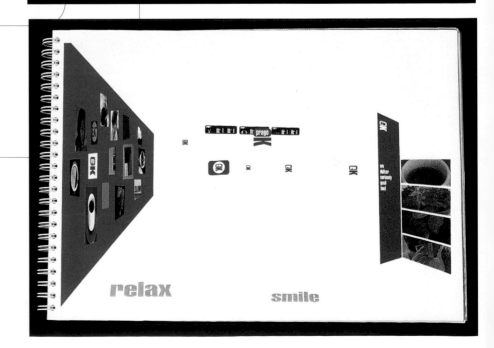

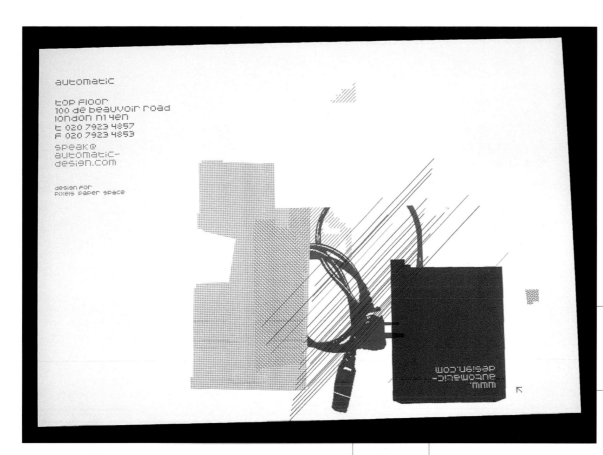

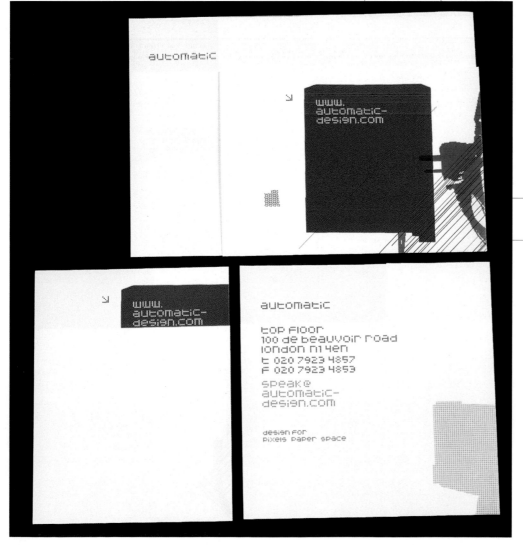

New Spaces Mailer
Designer: Automatic
Client: Self
Concept: "Our recent move into the physical space of our new studio and the upcoming creation of the digital space of our upcoming Web site influenced this multifunctional mailer. One strategic trim separates the sheet into two mailers, one announcing our new space and the other, sent later, announcing our Web site. Imagery of the cables and debris from the move cut across the trim and allow the Web site to literally 'plug in' when the two mailers are brought together."

After working in Chicago as a graphic designer for The Design Partnership, R. Valicenti Design was founded in 1981. But in 1987, Rick Valicenti set out to reinvent himself by creating Thirst. Thirst is a firm devoted to art with function. Valicenti's passion for design and the advent of new technology made for a dynamic marriage of imagery and inspiration. Thirst's creative versatility continues the pursuit of elusive ideals of intelligence and beauty within today's world of commerce.

In 1993, Valicenti founded Thirstype, a type foundry devoted to the typographic expression of our time. Most recently, Valicenti formed 3st2, a firm devoted to strategic identity design excellence in all digital media. With his various endeavors, Valicenti's clients include Gilbert Paper, Gary Fisher Bikes, The Chicago Board of Trade, Herman Miller, The Monacelli Press, Skidmore and The Illinois Institute of Technology School of Architecture.

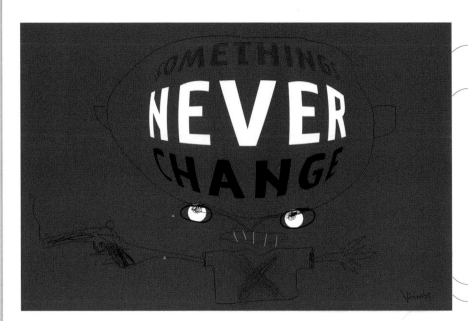

Some Things Never Change
Designer: Rick Valicenti
Client: P+R Group/ national display service bureau
Concept: The news.

Electronic Literature Organization Logo
Designer: Rick Valicenti
Client: Electronic Literature Organization/nonprofit community of writers and programmers
Concept: Geometry and glyphs.

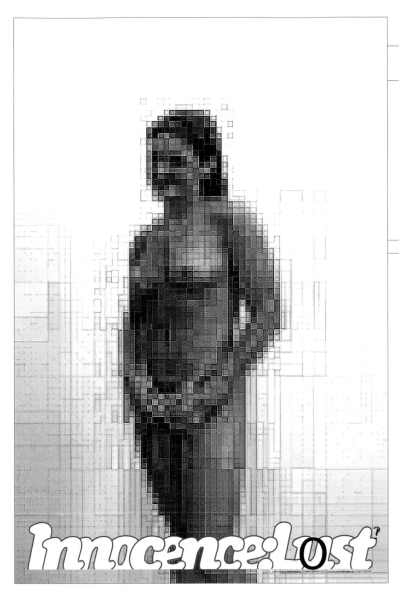

Innocence Lost/Innocence Lust
Designers: Rick Valicenti, Chester
Client: Self (for Thirstype)
Concept: The Internet, growing older, acting more lecherous.

NEW-NEU
Designers: Rick Valicenti,
Gregg Brokaw
Illustrator: Gregg Brokaw
Client: Gilbert Paper/premium
uncoated paper
Concept: Super–70s graphics.

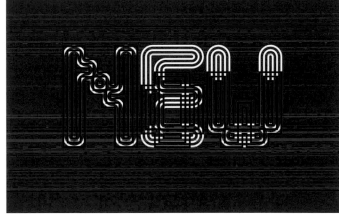

First Impressions
Designers: Rick Valicenti,
Petra Klusmeyer
Illustrators: Rick
Valicenti, Patricking
Client: Gilbert
Paper/premium
uncoated paper
Concept: Technology
and touch.

Popglory is a model of efficient ideological aberration and visual distortion. Featuring a futuristic media processor, Popglory's diverse applications allow unique session implementation on multiscalable projects.

The Electric Lauwn
Designer: Christian Daniels
Client: Syracuse University School of Architecture, for the "Landscape Architecture and Its Representation in POP Culture" exhibit
Concept: According to Daniels, the inspiration for this piece was "the opening of David Lynch's 1986 Blue Velvet. He uses the interior of the lawn to symbolize the film's exploration into the dark side of everyday life. The carefully tended layer of grass represents both the suburban ideal and its latent nightmare, the menace lurking behind idyllic surfaces."

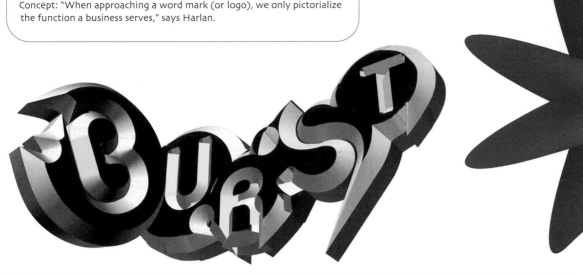

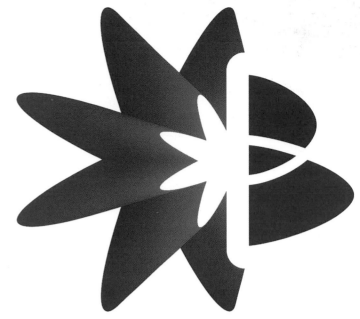

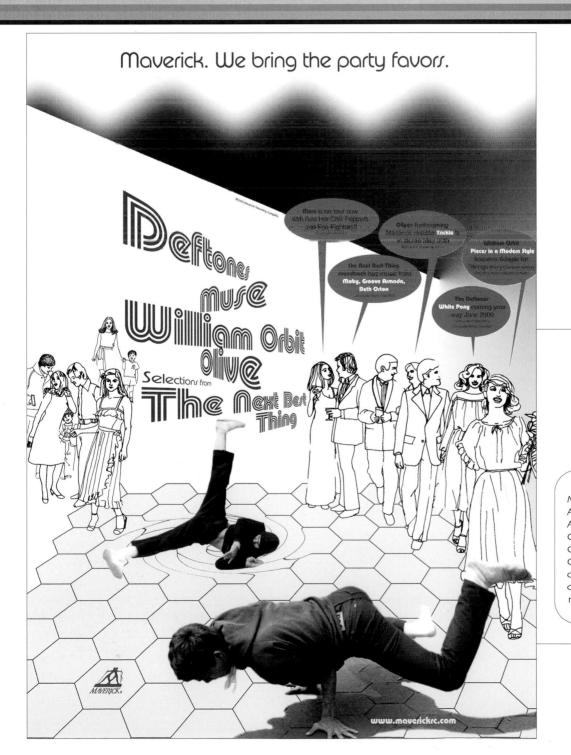

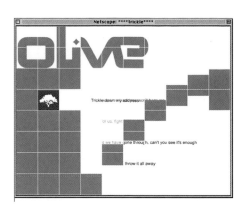

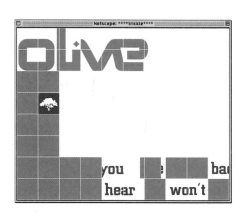
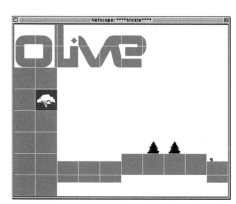
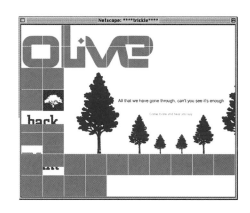

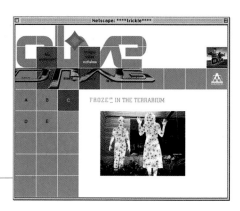
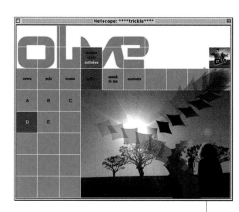
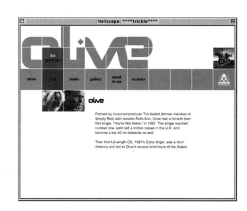

Olive Web Site
Art directors: David Harlan, Kim Biggs
Programmer: Happy Tsugawa-Banta
Illustrators: Glen Nakasako, David Harlan
Photographers: David Harlan, Zoren Gold
Client: Maverick Recording Company/Record label
Concept: To mix nature and technology. "A bar code writhes to form a tree," says Harlan. "The tree becomes a forest. The forest, however, moves as a machine would move it, always containing the underlying element of opposing duality."

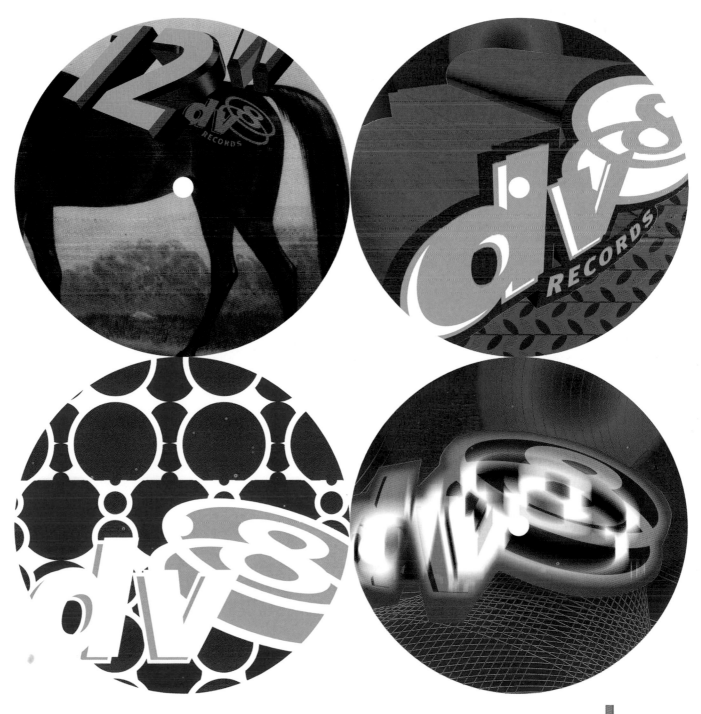

Designer: David Harlan
Client: DV8 Records/Record label
Concept: Harlan describes these pieces as "a vortex of curiosity, inviting the DJ to 'play.'"
He adds, "The larger challenge was to prominently feature this record label's logo each
time and not bore anyone."

Founded by Michelle Borghi and based in Dallas, Texas, Brainstorm, Inc. emerged as a graphic design and advertising firm in March 1989 and rapidly developed a reputation for producing highly creative marketing communication materials. Brainstorm successfully blends marketing strategy with innovative design to achieve extraordinary results. Brainstorm's capabilities range from print to three-dimensional design, with a specialization in corporate branding. Brainstorm also excels in the digital market. Brainstorm's clients expect unique and unusual approaches to problem-solving and a service-oriented environment. Brainstorm has been recognized internationally by HOW, Print, Graphis, Communication Arts, New York Art Directors, AIGA Graphic Design Annuals and North Light Books.

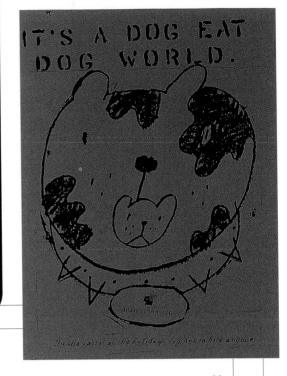

Dog Eat Dog World
Designer: Chuck Johnson
Client: Self
Concept: "This was our company holiday card/poster that was sent to clients, friends and vendors," explains Johnson. "We wanted to stand out from the normal holiday clutter, so we gave it some bite."

Rough, October 1999
Designers: Chuck Johnson, Adam Hallmark, Tom Kirsch, Ryan Martin
Illustrators: Chuck Johnson, Adam Hallmark, Tom Kirsch, Ryan Martin, Gary Baseman
Photographers: Phil Hollenbeck, Pat Jerina, Danny Hollenbeck
Client: Dallas Society of Visual Communications/nonprofit organization
Concept: "Being a Halloween issue of Rough and with Gary Baseman as the featured illustrator, we went to town with an erie Halloween feeling throughout. Rough is a quasimonthly publication produced pro bono in its entirety by, for and about the members, associates and friends of DSVC, one of the country's largest advertising clubs."

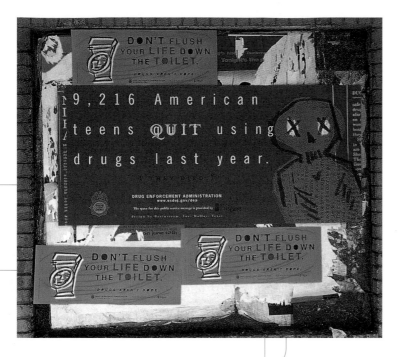

DEA Public Service Posters
Designers: Chuck Johnson, Jeff Dey
Client: Drug Enforcement Administration
Concept: To create posters that appeal to the youth.

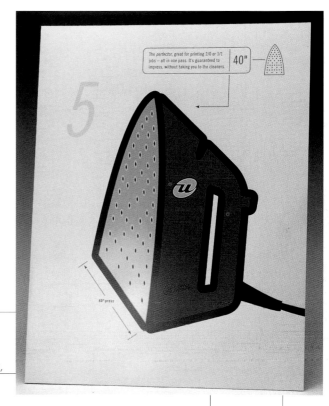

Anything Goes
Designer: Chuck Johnson, Adam Hallmark, Ryan Martin, Tom Kirsch
Illustrators: Chuck Johnson, Adam Hallmark, Ryan Martin, Tom Kirsch,
Colton Johnson
Client: Ussery Printing Company/offset lithography
Concept: Anything goes. "The client just wanted to show off the
capabilities of their new presses," says Johnson.

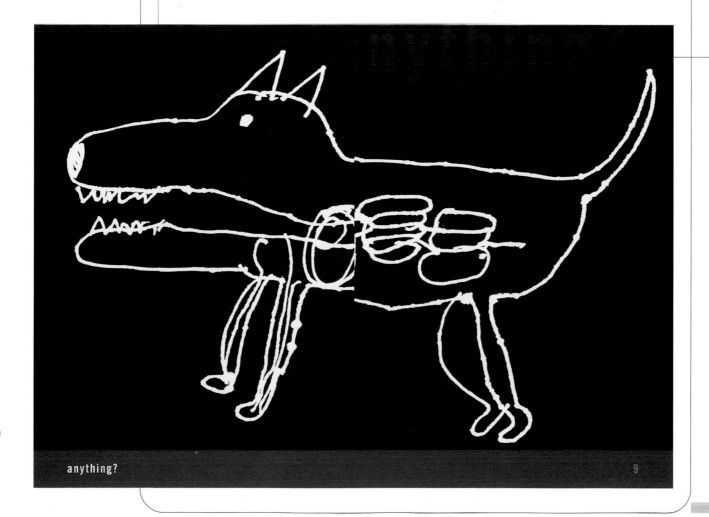

Founded in Seattle in the summer of 1987, Modern Dog got their first lucky break when K2 Snowboards became a client because they mistook Modern Dog for another design firm (a highly recommended approach, according to the staff of Modern Dog). Since then, their client list has expanded to include collateral design for the Tacoma Art Museum and Nordstrom, logo and Web site development for Planet 7 Technologies, book covers for Simon & Schuster, soap packaging design for Blue Q and product development for Swatch Watches.

Most recently, their work has been accepted into the permanent archives at the Denver Art Museum, the Smithsonian Institute's Cooper-Hewitt National Design Museum in New York City, the Library of Congress, Western Washington University's Art Gallery and the Experience Music Project in Seattle. In addition, museums in Germany, Finland, Taiwan, France, Mexico, Hungary, the Czech Republic and Denmark have exhibited and collected Modern Dog posters.

With a style that has been described as "adventurous" and "homespun," the studio has consistently pushed the envelope of commercial acceptability, producing work that appears raw yet is highly sophisticated.

Amphetazine
Designers: Michael Strassburger, Robynne Raye
Art Directors: Michael Strassburger, James Fisher (Seattle Public Health Department)
Client: Seattle Public Heath Department
Concept: Raye of Modern Dog describes the project: "Amphetazine is a fanzine-style informational booklet directed at gay men who shoot crystal meth. This particular population has the highest rate of HIV transmission—while tweaking on crystal meth, some men are able to have crazy sex all night long—so not only are they having unprotected sex much of the time, but they are injecting drugs. To get a group like this to read we needed to make sure this didn't feel like just another piece of health department propaganda that says 'NO! NO! NO!' This had to take the view that these people are going to be doing this and if that's the case, they should do it as safely as possible and have information available."

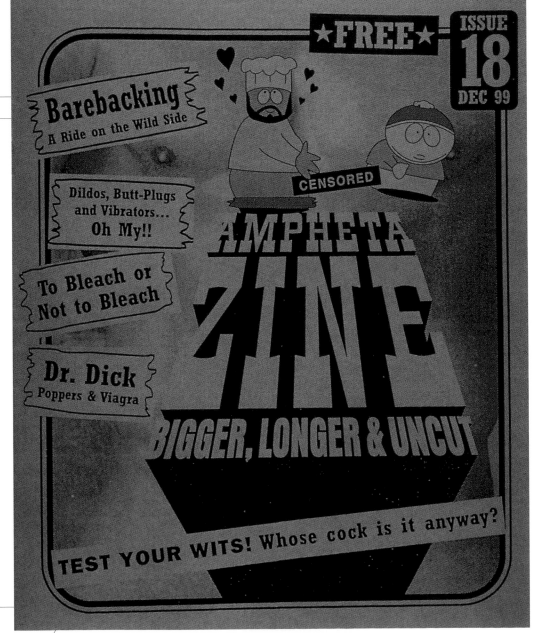

WHAT'S LOVE GOT TO DO WITH IT?

By Ed Aaron

.Tina Turner must have been truly tweaked to let herself get all messed up by Ike.

But look who's on top now!

Still, I can understand — *love*, or at least what we think is *love*, can make us do some pretty messed up stuff.

Q: If I had on STD, wouldn't I know it?

So this is supposed to be a "*love*-filled" issue of *AmphetaZINE*. And since that's the case, I decided (with a little coaxing from fellow NEON Peer Educators) to sit down and talk about my own experience with *love*. I'll admit to a certain amount of near terror about this whole business for two reasons.

First, I'm more comfortable talking with people. A writer I'm not. It's hard enough to find the right words to speak sometimes, let alone to try writing them. It helps to admit being an amateur at this — *it was the boss's idea*. Anyway, I think severe boredom must have brought it on.

The second reason for my terror is that I must admit how little I know about or have experienced *love* in my life. To me, it's been more of an abstract concept defined by religions, classical literature and Hollywood tear-jerk dramas. Remember? Joan Crawford all hot and bothered over some hunk of man-meat named Johnny Guitar I thought Mercedes McCambridge was gonna gersch all over herself for almost two thirds of that movie.

Love and Hollywood. "*If you played it for her you can play it for me. Play it Sam. Play As Time Goes By.*" Closest moment to Bogart crying like a pussy-whipped sissy in his whole career. People, we were supposed to fall for the "okey-doke" that *love* caused all that emotional titillation. My own theory is that it was just too damned hot in Casablanca. It is near the Equator, isn't it?

What other images are conjured up in my memory

regarding *l'amour*? Um... I wrote French. Oh yes, Patti LaBelle's ode to the working girl, honey. "*Voulez-vous coucher avec moi ce soir?*" After that song came out there were ho's all over America running around swearin' to high heaven that they had some Creole in them. No doubt followed by some Irish, some Dutch, some German, some Spanish, and a whole lot of Black folks just passin' by. Oh yeah. Let's sing about love. Why am I hearing the SOS band in my head all of a sudden? "*Baby we can do it, take your time, do it right, we can do it, Baby, do it tonight*" — Perhaps even longer if our checkout time ain't till noon.

I THOUGHT MERCEDES MCCAMBRIDGE WAS GONNA GERSCH ALL OVER HERSELF FOR ALMOST TWO THIRDS OF THAT MOVIE.

What I have known of *love* on a personal level — whether giving or receiving it — is best compared to a snowflake passing through a raging fire. Now you see it, now you don't. Today you'll feel it; tomorrow you won't. The only real, genuine, sincere, constant, and unquestioned *love* I've ever had in my life has come from my *biological* and my *adopted* families.

I am the second son of nine children, but was raised as an only child by my adoptive parents. We lived in a sixteen-room house on the corner of

R: Sometimes but not always. Many STDs, like chlamydia, gonorrhea and herpes can be in your throat, your dick or your butt without any symptoms.

Ask Dr. Dick

A forum for your sexual health queries.

Hey Dick,

Last Saturday, I got high, took a Viagra ('cause sometimes I get crystal-dick) and went to my favorite bathhouse for my weekly sex-capade. I had fucked around with a few guys and was feeling pretty fine... that is until the guy who was fucking me shoved a bottle of poppers under my nose. Afterwards, I got really dizzy and had to go home in a taxi. One of my friends told me that the reason I got dizzy was because of the poppers and Viagra. Also, my friend said that poppers are bad for me. What's up with that?

Dizzy in Seattle

I TOLD KENNY NOT TO TAKE POPPERS WITH THE VIAGRA!

Dear Dizzy,

As you have found out, the combination of poppers and Viagra can be very dangerous, perhaps even deadly. When used at the same time, these drugs can drop your blood pressure. Low blood pressure can leave you feeling light headed and dizzy and possibly cause you to faint or pass out. It could also cause heart or brain damage. You should consider yourself lucky.

Poppers

are various kinds of nitrite or nitrate inhalants. Originally, they were made to treat certain heart problems. But in the gay community, they came to be used as sexual (and dance) stimulants. Some gay men inhale poppers to help relax the anal sphincter (butt hole) when they are getting fucked or fisted. Others find that orgasm is more intense with a quick whiff. When you inhale poppers, your blood vessels relax. This allows more blood to circulate through your body. Poppers used to be made of amyl nitrite. Congress banned the sale of some kinds of nitrites in 1990 because they were no longer the best heart medicines. Also, legislators found out that people were using them for fun and that they could be dangerous to a person's health. Popper manufacturers got around this ban by using different kinds of nitrites and calling them deodorizers, among other things. These products have never been tested on humans. So, their short and long-term medical risks are not known.

POPPERS, HIV AND STDS

The gay community has been looking at the effect of poppers on the immune system for years. Some studies show that poppers weaken the immune system. Other studies show a link between popper use and increased risk of getting HIV and STDs. Right now, no one really knows why this is. But there are a few good explanations.

✓ Poppers cause the blood vessels to dilate — become more open. This makes more blood flow to vessel-rich areas like the anus. This could make it easier for HIV to get into the blood stream during anal sex.

✓ Some people use poppers to reduce the pain they feel with anal sex. If you use poppers to have long and hard butt sex beyond your normal limits, tears are more likely to happen. You might not feel a tear inside your butt. Even a tiny tear can be an opening for HIV or other bugs to get into your blood stream.

✓ As a group, gay men who use poppers might be having more anal sex or more sex partners. This means more opportunities to get exposed to HIV and other STDs.

The truth is we aren't sure why popper users are more likely to get HIV and other STDs. But studies do show that there is a real connection.

(cont'd on next page)

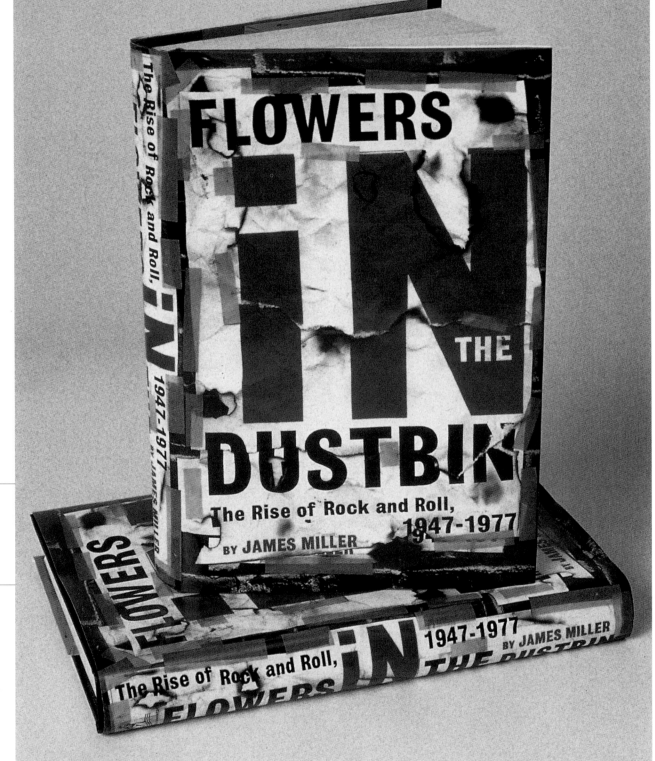

Flowers in the Dustbin Book Cover Designer: Robynne Raye Client: Simon & Schuster/publisher Concept: Raye says a past piece of design inspired this work. "[I based this design on] a poster for a play called Substance of Fire that I created in 1992 using a blowtorch to burn up the posters."

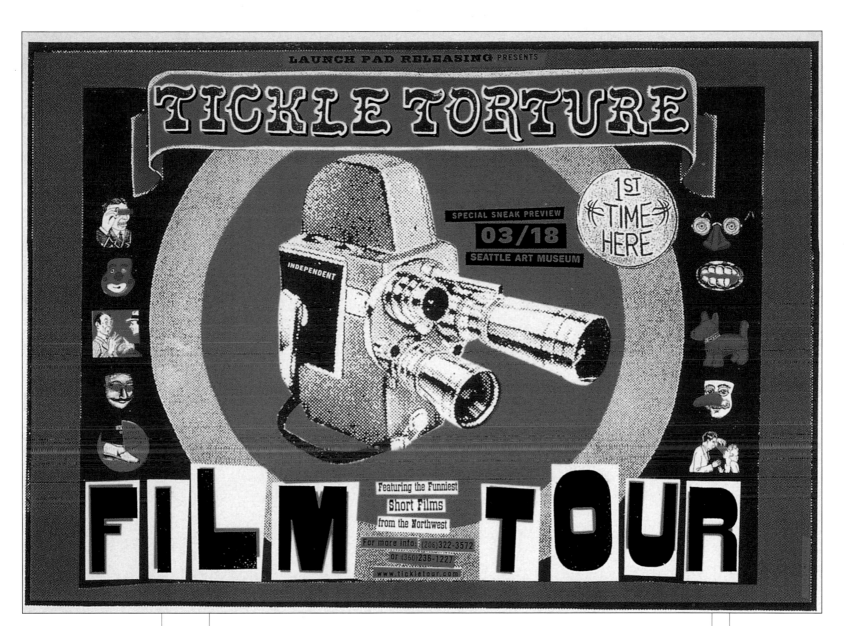

Tickle Torture Film Tour
Designer: Robynne Raye
Client: Launch Pad Releasing/Independent films
Concept: Old circus sideshow posters. "I wanted to create a do-it-yourself look or attitude for this poster."

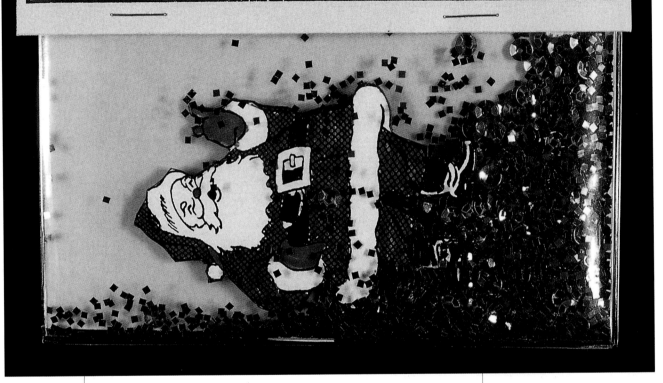

Warner Bros. Records gave a bunch of money to people who really needed it, so you get this.

Happy Fuckin' Holidays.

All materials are toxic. Don't eat it or throw it in anybody's face.

Happy Fuckin' Holidays
Designer: Michael Strassburger
Client: Warner Bros. Records
Concept: "This holiday greeting was a reaction to the endless politically correct, safe greeting cards."

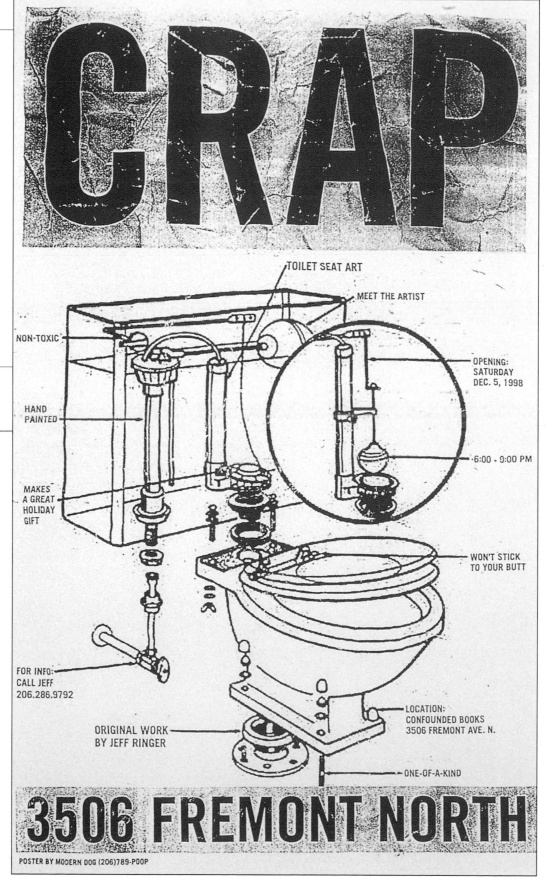

Peter Cho is a graphic designer and computer programmer. Cho works at Imaginary Forces, a conceptual film, broadcast and environmental design firm in Hollywood, California. He holds a master of science degree in media arts and sciences and a bachelor of science in engineering from the Massachusetts Institute of Technology.

As a member of the Aesthetics and Computation Group at the MIT Media Laboratory, led by Professor John Maeda, Cho worked on independent research projects to explore the possibilities for interactive and temporal typographic forms.

His honors include a gold award in the 1998 I.D. Magazine Interactive Media Review, the 2000 Tokyo Type Director's Club Interactive Design Award and inclusion in Print magazine's 2000 New Visual Artists Review.

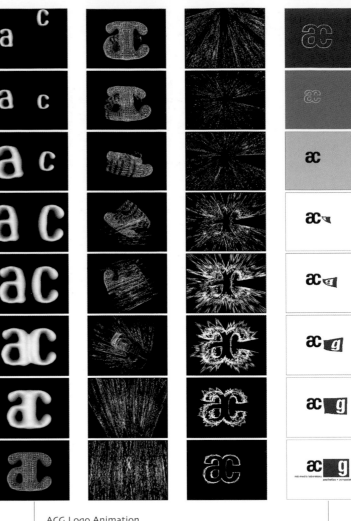

ACG Logo Animation
Art director: Peter Cho
Client: MIT Media Laboratory Aesthetics and Computation Group/research laboratory
Concept: "This ten-second animation demonstrates the fusion of the A (aesthetics) with the C (computation) through a series of three-dimensional transformations," explains Cho. "Most of the animation was coded on a SGI machine using OpenGL and C++."

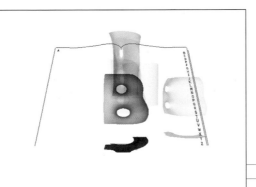
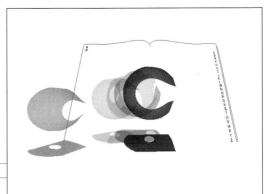

The Alphabet Zoo
Art director: Peter Cho
Client: Self
Concept: "The Alphabet Zoo is an interactive storybook featuring the twenty-six letters. Each letter is a three-dimensional creature, whose personality is reflected in a playful animation. This award-winning piece was created as part of my independent research at the MIT Media Lab."

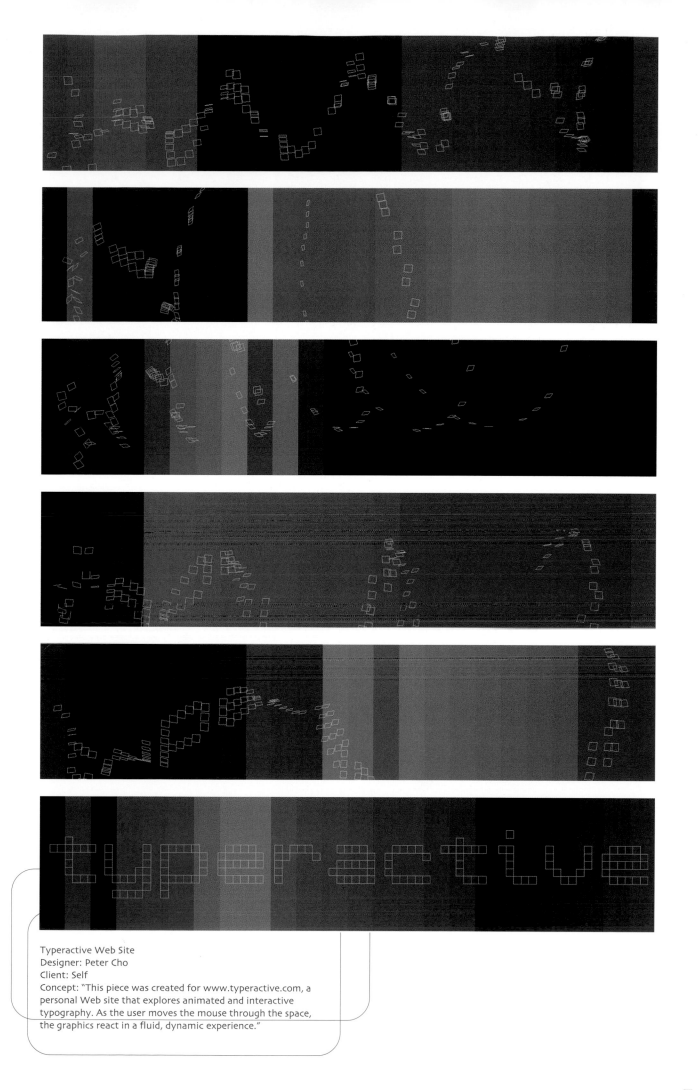

Typeractive Web Site
Designer: Peter Cho
Client: Self
Concept: "This piece was created for www.typeractive.com, a personal Web site that explores animated and interactive typography. As the user moves the mouse through the space, the graphics react in a fluid, dynamic experience."

The Designers Republic is located in SoYo, North of Nowhere. It declared independence from the London Blahs Bastille Day 1986. From pixel-piracy-on-the-high-tech to new and used American expressionism, from buy-nothing-pay-now to Brain-Aided Design, and from The Pho-ku Corporation to The Peoples Bureau For Consumer Information, The Designers Republic is wherever you are.

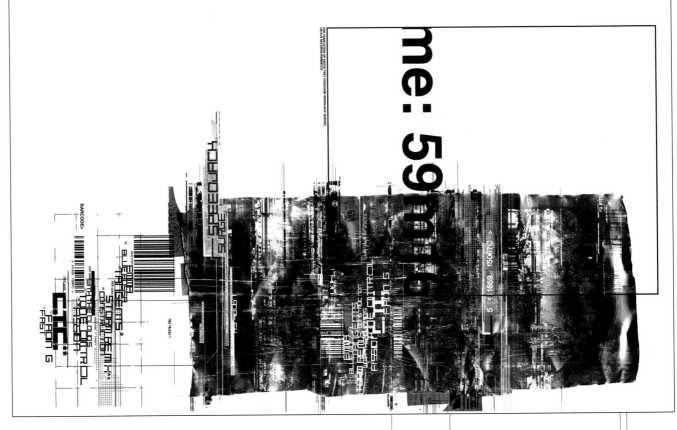

Speedjack Surge 12" LP
(Customized Adaptation)
Designer: The Designers Republic
Client: Speedjack, R+S Records (Belgium)/early-warning alarm systems
Concept: The Designers Republic describes this piece: "Coke can ripped open and scanned. Jacking on extrasugar, extracaffeine buzz-saw sliced type. Surge speeding on (dis)stressed, uncontrolled, sporadic communication. Fifty-nine minutes sixteen seconds of sound. Fifty-nine minutes sixteen seconds of vision."

Murray + Vern Catalog
Designer: The Designers Republic
Photographers: Lord Peter Ashworth,
Jeremy Chaplin, Kevin Davies
Client: Murray + Vern/fetish
fashion designers
Concept: "Impossible architecture vs.
improbable erotica crush collision.
Well built. Nice curves. Impressive
facade. Dominant structure. Catalog
for Murray + Vern's rubber clubber-
clobber fetish wear. Build and
bondage. Six-color sex
and deconstruction.
Satisfaction guaranteed."

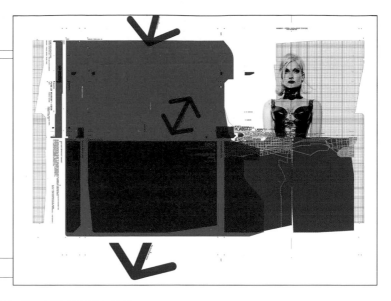

Fosters Ice Billboard Project, Limited Edition One of One (Contextualized)
Designer: The Designers Republic
Client: Fosters
Concept: "2064 black-and-white white laserprints. 108 color laserprints. 100 I Love My DR
stickers. Four black marker pens. One red marker pen sacrificed for the greater glory of an
Australian beer brewed in the UK. Art for alcohol. Street art expressionism. Typographic
implosion. Conceptual bullshit up-over crushed and flattened Fosters beer can down under.
Tinny. Handcrafted digital output. The new and improved godlike genius of Oscar Wilde."

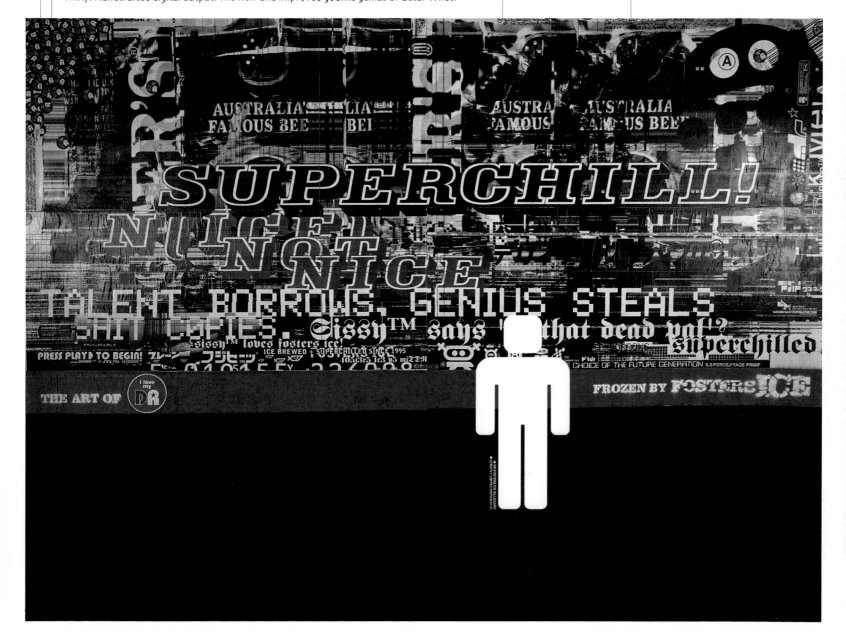

Satoshi Tomiie Full Lick 12" LP
Designer: The Designers Republic
Photographer: Michael C. Place
Client: Sony Music Japan
Concept: "Three dimensions in two
dimensions in three dimensions.
Buildings occupying time not space.
Record covers with directions. See
for yourself."

The Designers Republic Department Stores Are Our New Cathedrals
(From the DR M-Art Exhibition) (Dissection)
Designer: The Designers Republic
Client: Self
Concept: "First DR poster 1989 redeveloped for 1998 for DR M-Art
(Modern Art) Exhibition. Art for sale. Artist as commercial. Artist as
product—art as diffusion branding. Emperor's new clothes sponsored
by market forces. Selling as art. Selling art: the idea. The godlike
genius of Mark Stewart. The godlike genius of The Pop Group."

Barry Ament, Coby Schultz, George Estrada and Mark Atherton comprise Ames Design. The small four-man shop puts up big numbers, with a client list that boasts Pearl Jam, MTV, Neil Young, Phish, Amazon.com, Nike, Powerbar, K2 and Ride Snowboards, and Absolut, to name a few.

Their impressive work has garnered the four Ames artists a fair bit of recognition. In addition to having their work featured in numerous magazines and books, they have won several design competitions and they even landed a Grammy nomination for the 1998 Pearl Jam "Yield" CD and album packaging.

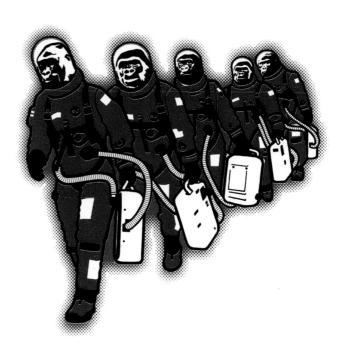

PEARL JAM 2000

Maastricht - June 12th Brussels - July 2nd Rotterdam - July 3rd

Ames Design / Scribellum Press

Space Apes
Designer: Mark Atherton
Client: Pearl Jam/rock band
Concept: "Pearl Jam's latest album has an outer-space theme to it. I imagine riding the tour bus is a lot like riding the space shuttle around the world."

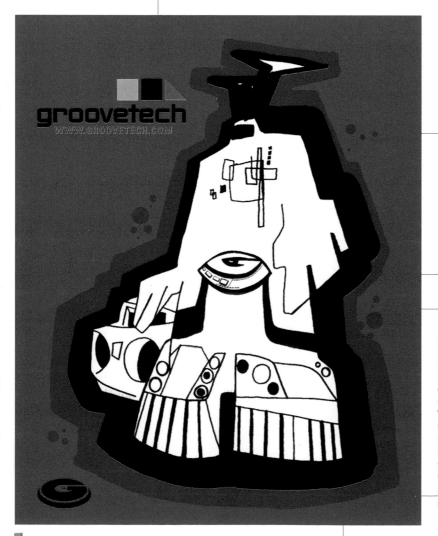

Groovetech Sticker
Designer: George Estrada
Client: Groovetech.com/on-line radio station in underground dance music
Concept: According to Estrada, "Groovetech provides a high-tech service for high-tech music, but they wanted the soulfulness of the music and what they're doing to be the focus of their imaging. It's more of a down-to-earth, street-level type of feel."

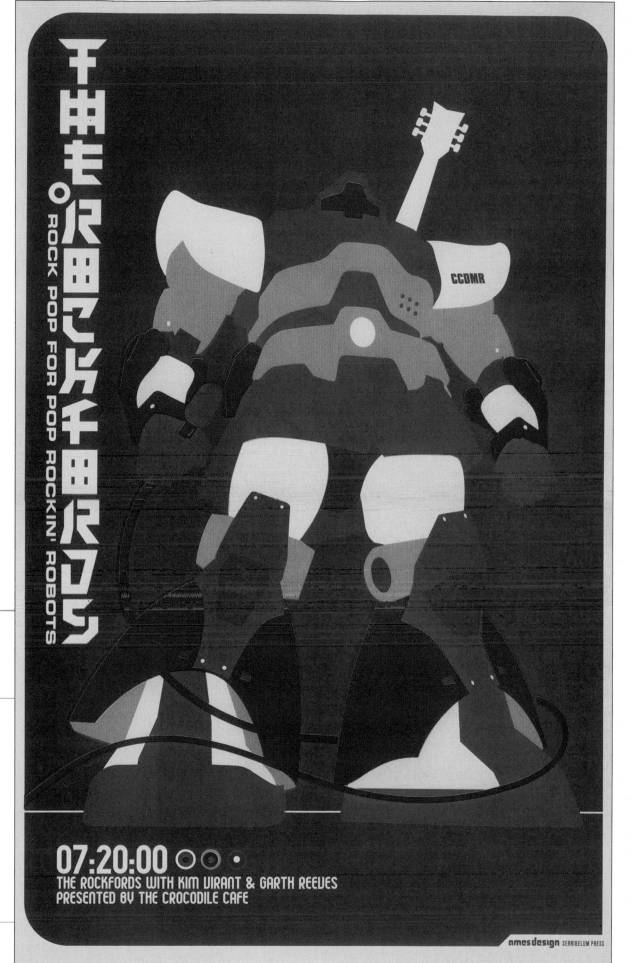

THE ROCKFORDS
ROCK POP FOR POP ROCKIN' ROBOTS

CCDMR

07:20:00 ◉◎•
THE ROCKFORDS WITH KIM VIRANT & GARTH REEVES
PRESENTED BY THE CROCODILE CAFE

ames design SERRIBELUM PRESS

Pop Rockin' Robot
Designer: Mark Atherton
Client: The Rockfords
Concept: "The Rockfords is
a local Seattle rock band,
but their main fan base is in
Japan. The band wanted to
do an image that was
influenced by Japanese
animation or pop culture
but with an American
twist," says Atherton. "I
just wanted a chance to
draw a robot. I put a
microphone in his hand and
a guitar strapped to his
back to make him
rock-n-roll ready."

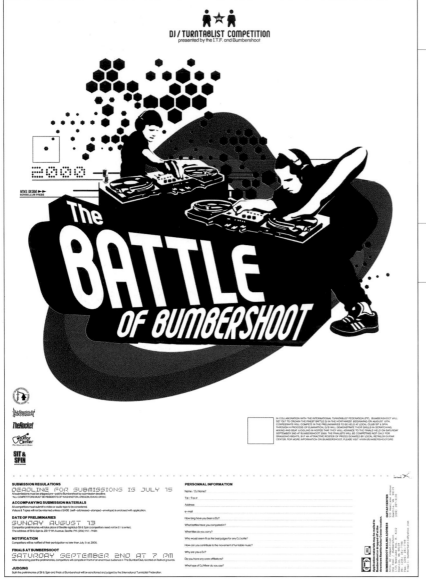

The Battle of the Bumbershoot
Designer: Mark Atherton
Client: One Reel Entertainment/creation and direction of festivals
Concept: "The Battle of the Bumbershoot is a man vs. man DJ competition. DJs will perform an array of 'tricks' while mixing beats and samples," says Atherton. "With DJs constantly trying to outdo each other, these competitions are as visual and physical as they are audible. The competing DJs go through several rounds of elimination until only the best DJ is left standing—word!"

Astar
Designer: Coby Schultz
Art director: Nick Sherman (K2 Snowboards)
Client: K2 Snowboards
Concept: "The design was centered around a sci-fi space theme. This was one design in a whole line of boards I created, and each one looks like some weird abandoned structure you might come across while lost in space … should that ever happen," says Schultz.

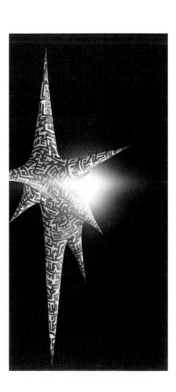

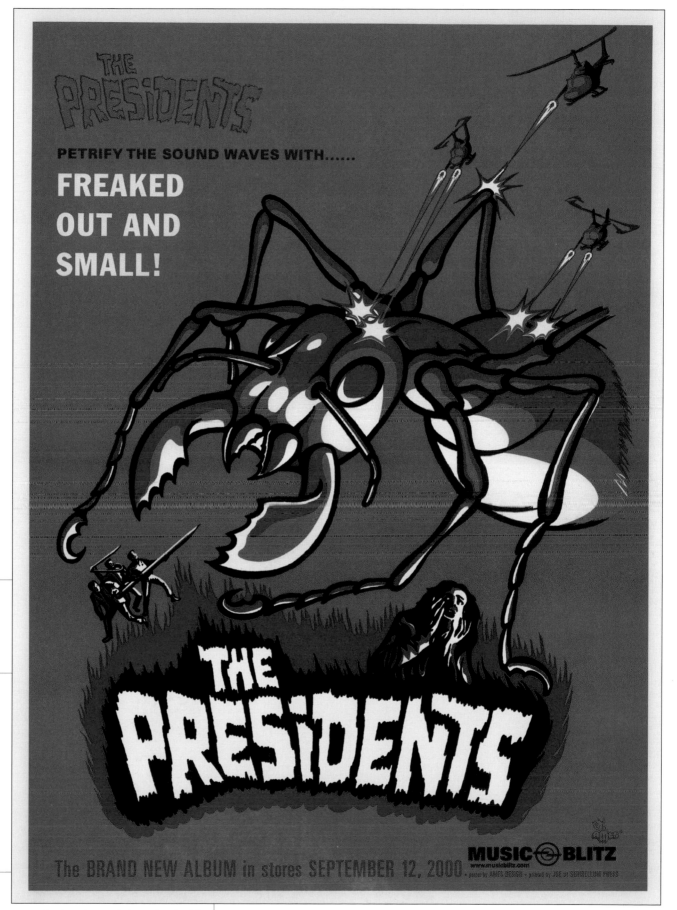

Presidents Poster "Freaked Out & Small"
Designer: Coby Schultz
Client: Music Blitz (Presidents)/on-line music promotion
Concept: "The title of the Presidents' new album—Freaked Out & Small—was the inspiration for this piece," explains Schultz. "There was no art direction, so it was pretty wide open with where I could go. I decided to take something small, an ant, and make it freaked out. B-movie posters from the 1950s and 1960s always made me laugh with how dramatic they were and always were better and more scary than the movies. I tried to re-create that drama and humor with this poster."

Zinzell is a New York City-based independent designer. Beginning as a "designer for hire" in 1987, Zinzell decided in 1995 to make the extra push needed to establish the studio in its current form. In 1999, his wife, Manon, a Dutch native with a background in architecture and branding, joined as studio manager and project director.

Extensive use of his own typeface design and photography, as well as a surreal utilitarian feel, makes Zinzell's work unique. His use of metaphors and the complexity behind simple surfaces gives his work a cerebral modern edge.

The studio's graphic design and art direction projects have encompassed a broad spectrum of clients such as Bloomingdale's, Sony, Tommy Hilfiger and Tourneau as well as numerous other companies. Zinzell not only designs for print, but works on Web, branding and identity, signage, video and packaging as well.

love_sex_desire LSD
contents

love_sex_desire ™

strange attractor

love_sex_desire
Designer: Don Zinzell
Client: l.s.d., strange attractor fragrance/consumer fragrance
Concept: Twist on general commercial fragrance advertising.

fragrance

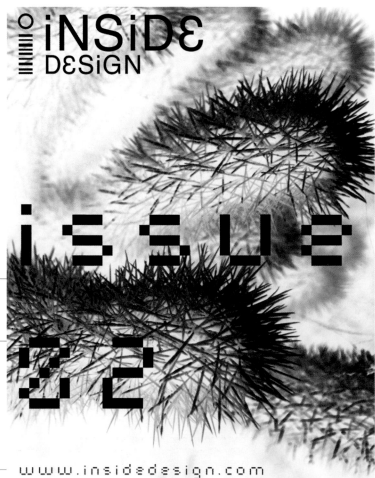

iNSiDE DESiGN

issue 02

Extreme Materials—Mailer
Designer: Don Zinzell
Client: Inside Design/design information resource
Concept: Extremities in material textures.

www.insidedesign.com

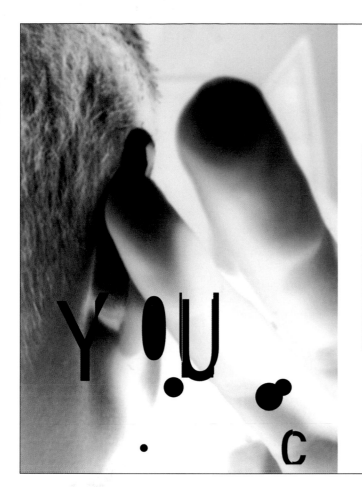

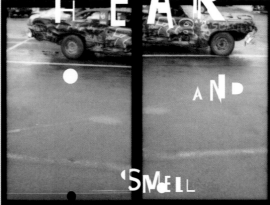

AND

HEAR

AND

SMELL

AND

TOUCH

AND

TASTE

YOU

C

Spread From Self-
Promotional Brochure
"Five Senses"
Designer: Don Zinzell
Client: Self
Concept: Visual
perception of
photography and type.

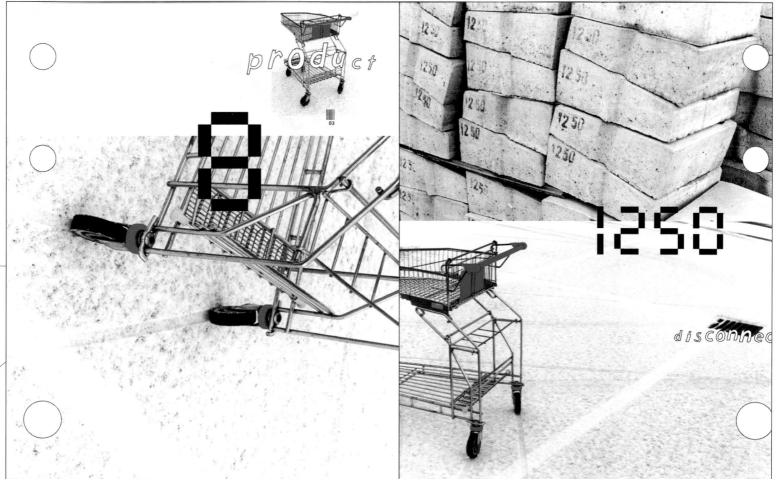

product

03

1250

disconnec

Addict Spread—Choice
Designer: Don Zinzell
Client: Addict Magazine/advertising and design publication
Concept: Shopping carts and their use as a metaphorical vehicle to communicate
consumer choice in a saturated market.

Spencer Drate, creative director, designer, CD consultant and author, has created award-winning CD packaging for many popular recording artists, including Bon Jovi, Lou Reed, U2, the Ramones, the Velvet Underground, Joan Jett and Talking Heads. One of the first to recognize and take advantage of the graphic possibilities of CD packaging, he recently curated the first CD Special Packaging Show at the One Club and VH1 Gallery in New York City with Jütka Salavetz. He is the author of Designing for Music, Cool Type, Cool Type 2wo, Extreme Fonts, Web Art and coauthor with Roger Dean and Storm Thorgerson of Album Cover Design 6. Drate is an active member and committee participant of the National Academy of Recording Arts and Sciences and the Art Director's Club, NYC. He has been given many design awards, including ones from the AIGA and the Art Director's Club. He has also been interviewed by many leading publications and appeared on MTV and VH1. His other focuses are music and corporate identity programs design.

Jütka Salavetz has freelanced for Justdesign for the past seventeen years. She coauthored several books with Spencer Drate and codesigned most of Drate's books' packaging. Many of her pieces, in addition to being shown in a variety of books, have won awards. The language of design is what brought Salavetz and Drate together, and their vision for infinite fantasies and new creations is what keeps them together.

N.Y. Gold "Manhole Cover" Identity
Designers: Spencer Drate, Dennis Ascienzo, Jütka Salavetz
Art directors: Spencer Drate, Dennis Ascienzo, Jütka Salavetz
Photographer: David Katzenstein
Client: N.Y. Gold
Concept: "A new identity associated with New York. This theme of manhole cover montage carried through on a direct-mail brochure," says Drate.

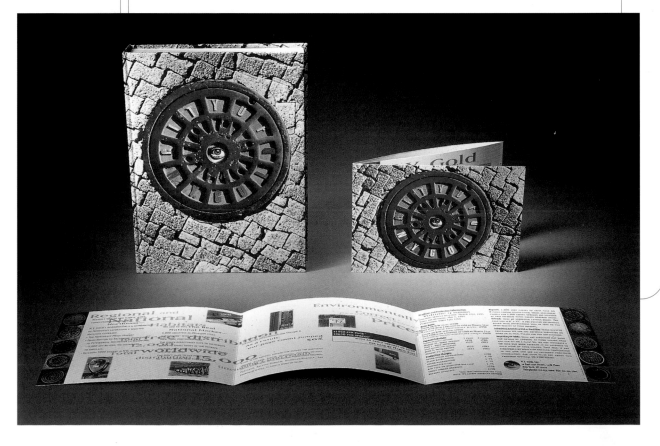

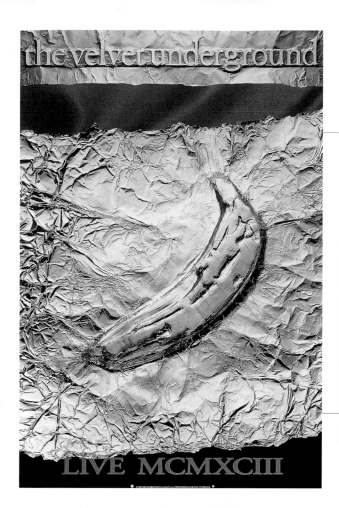

The Velvet Underground Live MCMXCIII Retail Poster
Designers: Spencer Drate, Jütka Salavetz, Dennis Ascienzo, Sylvia Reed
Art directors: Spencer Drate, Sylvia Reed
Photographer: Ted Chin
Client: Sire/Warner Bros. Records
Concept: "Metallic 'Andy Warhol' banana. A new identity carried over to CD packaging. To bring the classic Velvet Underground image to a new contemporary dimension."

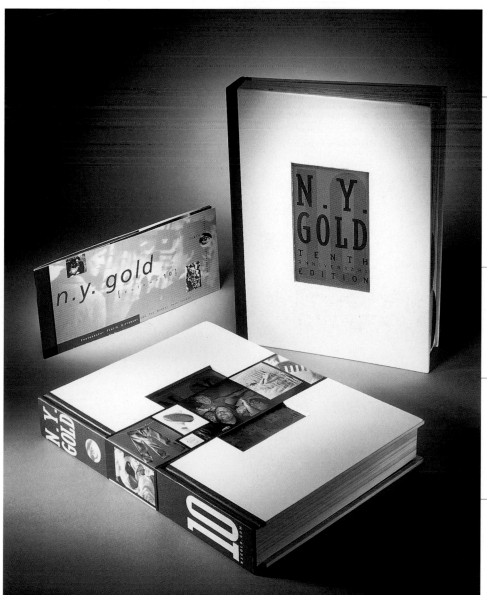

N.Y. Gold Tenth Anniversary Book and Direct Mailer
Designers: Spencer Drate, Jütka Salavetz, Dennis Ascienzo
Art directors: Spencer Drate, Jütka Salavetz, Dennis Ascienzo
Client: N.Y. Gold
Concept: "A special tenth-anniversary identity/design. The brochure has four metallic colors plus black with varnish and the book is four-color plus metallic gold. The cover is die cut and a bellyband wraps around the book."

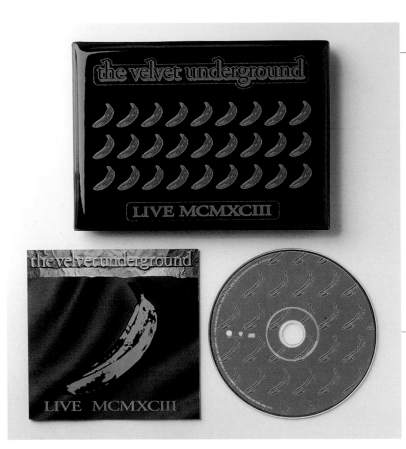

The Velvet Underground Limited Edition Retail CD
Designers: Spencer Drate, Sylvia Reed, Jütka Salavetz,
Dennis Ascienzo
Art directors: Spencer Drate, Sylvia Reed, Jütka Salavetz
Photographer: Ted Chin
Client: Sire/Warner Bros. Records
Concept: "Colorform concept using Day-Glo inks on peel-off
stickers adhered to cover. Our intent was to carry the 'metallic'
banana into a different contemporary visual dimension.
Reminiscent of the 1960s Day-Glo poster-era into a new form!"

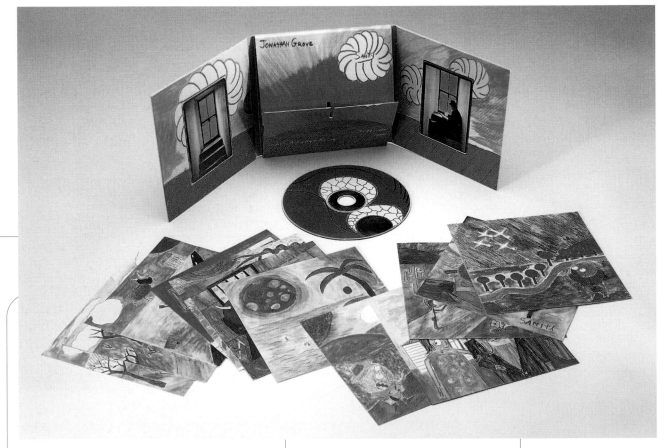

Sanity — Jonathan Grove
Designers: Spencer Drate, Jütka Salavetz, Jonathan Grove
Art directors: Spencer Drate, Jütka Salavetz
Illustrator: Jonathan Grove
Client: Fur Seal Records
Concept: "All artwork is in a foldout CD package multipanel with only minimal type (on spine only). Twelve
enclosed cards have artwork with lyrics on opposite side. Sticker on shrink-wrap has copy and artwork."

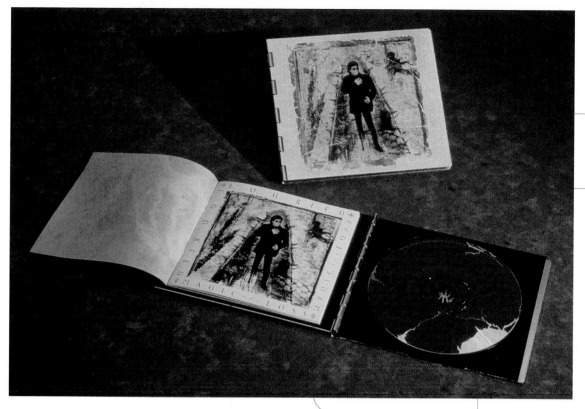

Magic and Loss — Lou Reed
Designers: Spencer Drate,
Sylvia Reed, Jütka Salavetz,
Dennis Ascienzo
Art directors: Spencer Drate,
Sylvia Reed, Jütka Salavetz
Photographer: Louis Tamme
Client: Sire/Warner Bros.
Records
Concept: "'Meta'-memorial
edition evokes metalbox and
silkscreen one-color photo on
cover. A volcanic color surge:
five-color CD disc with type
and intricate coloration where
CD disk color shows through
in various sections of artwork.
The black-and-white booklet
integrates photo, symbols and
typography."

Fear of Music — Talking Heads
Designers: Gerry Harrison,
Spencer Drate, David Byrne
Art directors: John Gillespie,
Gerry Harrison, Spencer Drate,
David Byrne
Client: Sire Records
Concept:"'Manhole cover'
embossed design grid.
Industrial concept integrated
with 'raw' typewriter font. Two
colors are used on the front
and back covers: Day-Glo
green on black-embossed
cover. This cover was
nominated for a Grammy."

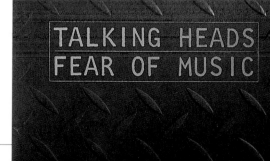

Creative director Rob O'Connor founded this London-based design consultancy in 1981. O'Connor studied graphic design both in Coventry and Brighton and began his design career in Brighton and then at Polydor Records in London. In the past nineteen years, Stylorouge has become a leading exponent of design for the music business. Their early work for artists such as Blur, Tears for Fears, Squeeze, Maxi Priest, Simple Minds, Alison Moyet and George Michael has made them renowned throughout the world. They have also designed for Catatonia, Kula Shaker, Soul II Soul, Jesus Jones, Geri Halliwell and David Bowie.

Their design philosophy has grown out of working mainly on arts-related work. Priority is placed upon representing what they see as the inherent personality of a project, realized in as original a way as possible, rather than following any particular house style.

Stylorouge, currently with a staff of eleven, has won many design and art direction awards, including regular Music Week awards and a D & AD recognition for the poster they created for Danny Boyle's film Trainspotting.

Proposal for European Launch of Photolibrary
Designer: Sheridan Wall
Client: European Photolibrary
Concept: "We wanted a concept that highlighted visual interpretation of words, creating a strong argument for using images," says Rob O'Connor. "The word string of 'boy', friendship and 'wreck' makes a word game of sorts: boy, boyfriend, friendship, ship, shipwreck, wreck. 'Make your head work' was a proposed copy line, inviting art directors to think laterally about their choice of imagery."

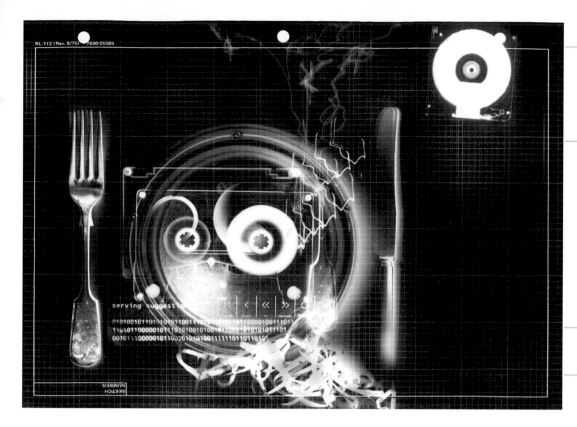

Editorial Illustration Audio Shareware
Designer: Robin Chenery
Client: Mac User/computer magazine

Stylorouge Self-Promotion
Designer: Tony Hung
Art directors: Rob O'Connor,
Tony Hung
Photographer: Merton Gauster
Client: Self
Concept: "This uses a word game.
The image of a chest X ray was
chosen to reflect the message
that a visual can work on two
levels. At first you look (a
superficially sensory experience),
and then you feel (emotional
experience)," explains O'Connor.

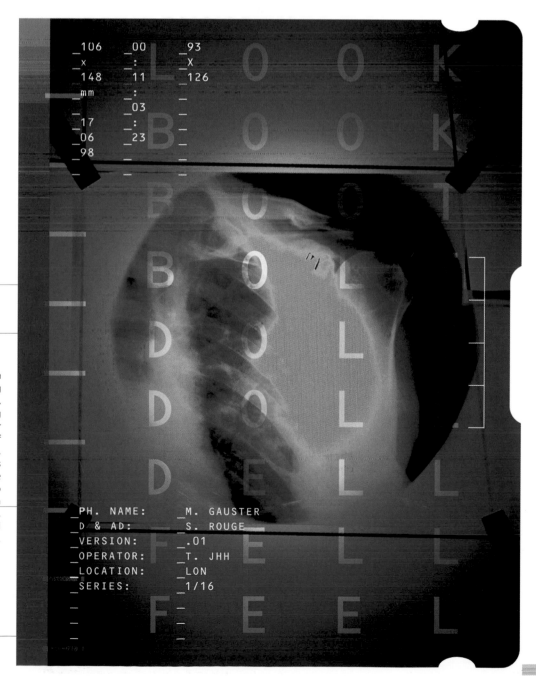

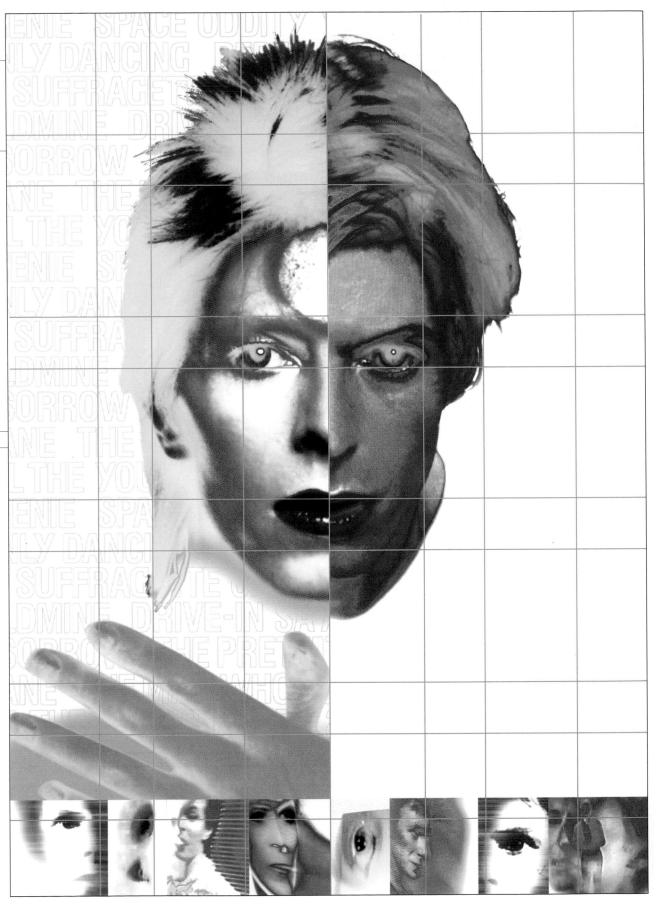

David Bowie
"Best Of" Packaging
Designers: Julian Quayle,
Sheridan Wall
Art directors: Julian Quayle,
Sheridan Wall
Photographers: Mick Rock,
Steve Schapiro
Client: EMI Records

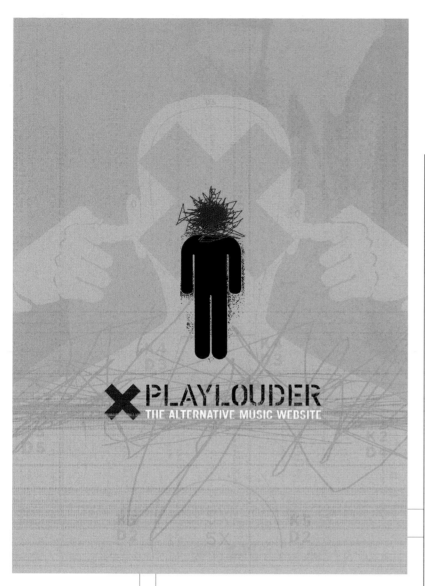

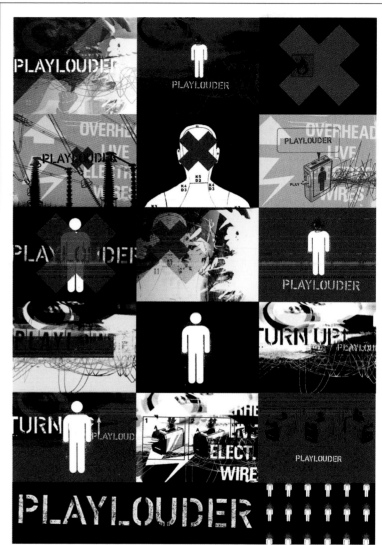

Playlouder Corporate ID/Web Site
Designer: Sheridan Wall
Client: Playlouder/alternative music Web site

WHY NOT ASSOCIATES

Why Not Associates (WNA) is a multidisciplinary design studio creating highly innovative and varied work. Established over a decade ago, WNA believes their vision and ideas can be applied to a wide range of media. Their optimistic and experimental attitude has led to projects ranging from designs for postage stamps to large-scale exhibitions and installations via publishing, corporate identity, public art and moving image.

Paramount to the variety of mediums WNA uses is an understanding of communication, with a crucial factor being the clients' willingness to share in their spirit of adventure and invention. Some clients include Nike, Fashionfile.com, Natural History Museum, Adidas, Smirnoff, The Green Party, BBC and The Royal Academy of Arts.

Virgin Records Conference Video
Designer: Why Not Associates (commissioned by Nancy Berry, Vice Chairman of Virgin Music Group; produced by Caroline True)
Client: Virgin Music Group
Concept: "This is a set of short films commissioned by Virgin Records Worldwide to be shown at their conference for Virgin executives in Los Angeles in April of 2000," say the designers at WNA. "Each artist's name was animated, pulsing in time to instrumental excerpts from one of their tracks. Artists featured included Perry Farrell, George Michael and Daft Punk."

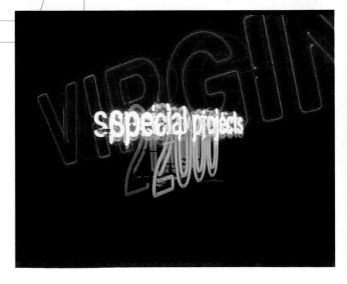

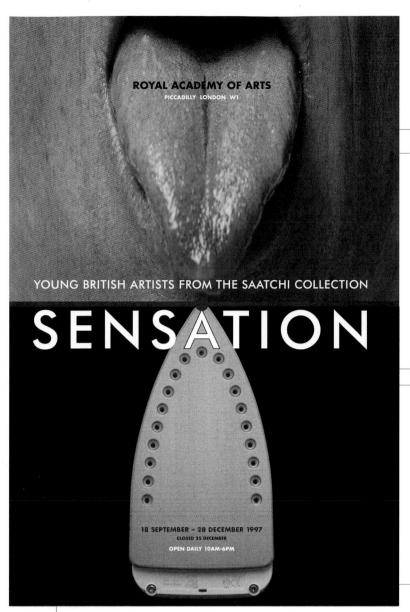

ROYAL ACADEMY OF ARTS
PICCADILLY LONDON W1

YOUNG BRITISH ARTISTS FROM THE SAATCHI COLLECTION

SENSATION

18 SEPTEMBER – 28 DECEMBER 1997
CLOSED 25 DECEMBER
OPEN DAILY 10AM-6PM

Sensation Poster
Designer: Why Not Associates
Client: The Royal Academy of Arts
Concept: "This poster was created to promote an exhibition of young British artists from the Saatchi Collection at The Royal Academy of the Arts."

Malcolm McLaren Fruit Machines
Designer: Why Not Associates
Client: Malcolm McLaren
Concept: "These fruit machines depict different eras of McLaren's life as part of McLaren's contribution to the exhibition 'Smaak' (meaning Oh, taste) in Maastricht, Holland."

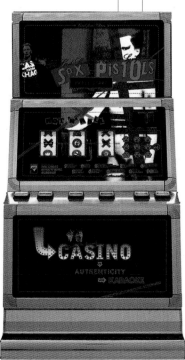
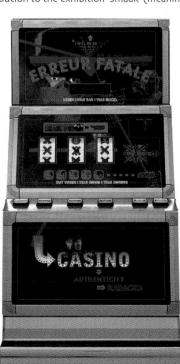
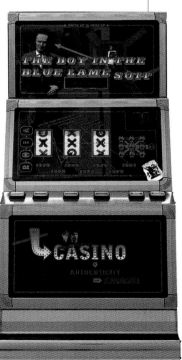
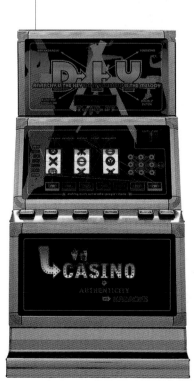

Stephen Farrell is the principal of Slipstudios. The components of the studio—"investigations" that include collaborative literature, visual essays, digital typography and music—each propel and inform the creation and distribution of the others. Farrell's font designs include Flexure, Missive, Entropy, Osprey and Indelible Victorian, all distributed through [T-26] font foundry in Chicago.

Since 1994, Farrell's type designs have focused primarily on digitally simulated handwriting derived from various European documentary cursive styles. His latest font, Volgare, was inspired by a handwritten manuscript from Florence in 1601, and it is one component of a broader multimedia exploration called The Volgare Project. Farrell's collaborative efforts have been published on the pages of Émigré, Typography Now Two, Private Arts Literary Journal, electronic book review and The Pannus Index. Farrell has won numerous awards, and he teaches design and typography at The School of the Art Institute of Chicago and The Illinois Institute of Art in Chicago. He studied visual communication at The Ohio State University in Columbus.

The Pannus Index
Designer: Stephen Farrell
Senior editor: Vincent Bator
Client: The Pannus Index/
literary journal
Concept: "Is the book form merely a container for language which lends its authority and a certain cache?" asks Farrell. "The suit celebrates the romantic myth of the author while parodying this common sentiment."

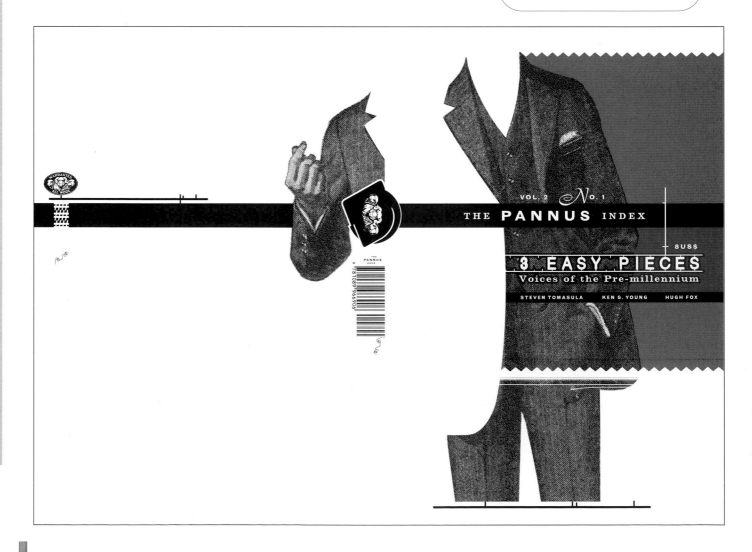

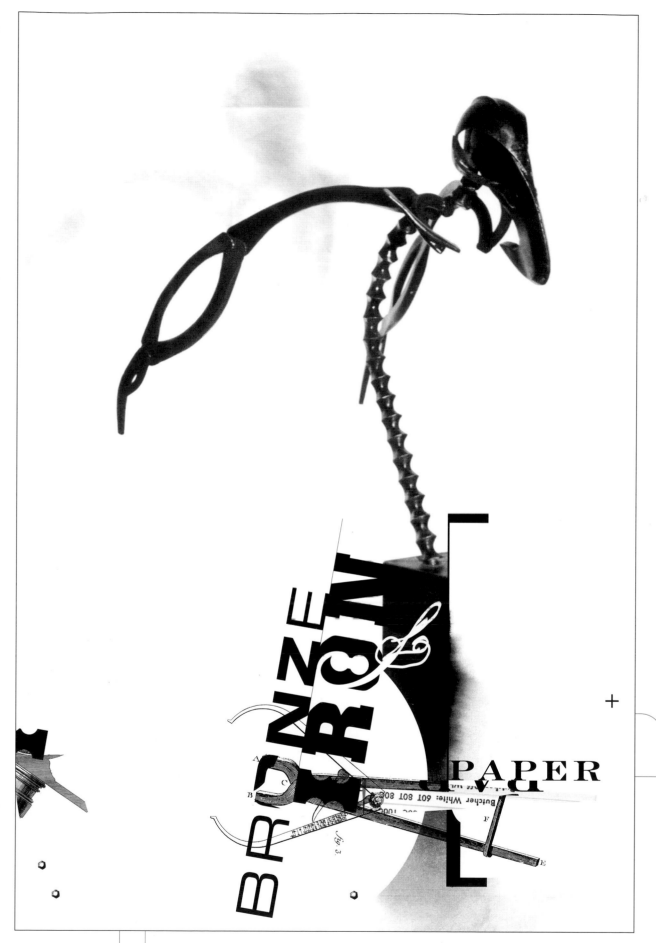

Bronze Iron & Paper
Designer: Stephen Farrell
Sculptor: Dervella McNee
Photographer: David Haj-Abed
Client: Artists' Liaison ATC Gallery/art gallery
Concept: "What more potent contrast than the mediums of iron and paper? My initial message with iron sculptor Dervella McNee inspired an aesthetic of muscular fluidity for this gallery card. We constructed both gallery space and gallery card around this notion of weighted space, of the lightness of being heavy."

la Scrittura, la Memoria
Meliore
Designer: Stephen Farrell
Illustrators: Stephen Farrell,
Jiwon Son
Writers: Steve Tomasula,
Daniel X. O'Neil, Stephen
Farrell
Photographer: Matt Dinerstein
Client: Émigré/magazine and
font distributor
Concept: "Volgare was inspired
by an original manuscript, a
death record penned by an
anonymous clerk in Florence in
1601. A process of meticulous
dissection and mimicry yielded
over five hundred characters,
including multiple versions of
each letterform, ligatures and
terminals, all of which allow
for a more convincing
simulation of the varied marks
of actual handwriting. This
project led to inquiries on the
history of the individual and
the social self which we
published in Émigré 38 as 'la
Scrittura, la Memoria Meliore.'"

The Gregg Bendian Project
Designer: Stephen Farrell
Writer: Brooke Bergan
Client: Private Arts/literary journal
Concept: "Poet Brooke Bergan
spontaneously generates text while
watching performances of music or
dance. For her review of a
percussion-based jazz trio called The
Gregg Bendian Project, I reacted with
a performative visual presence to
counterpoint the very rhythmic
cadences running through the text."

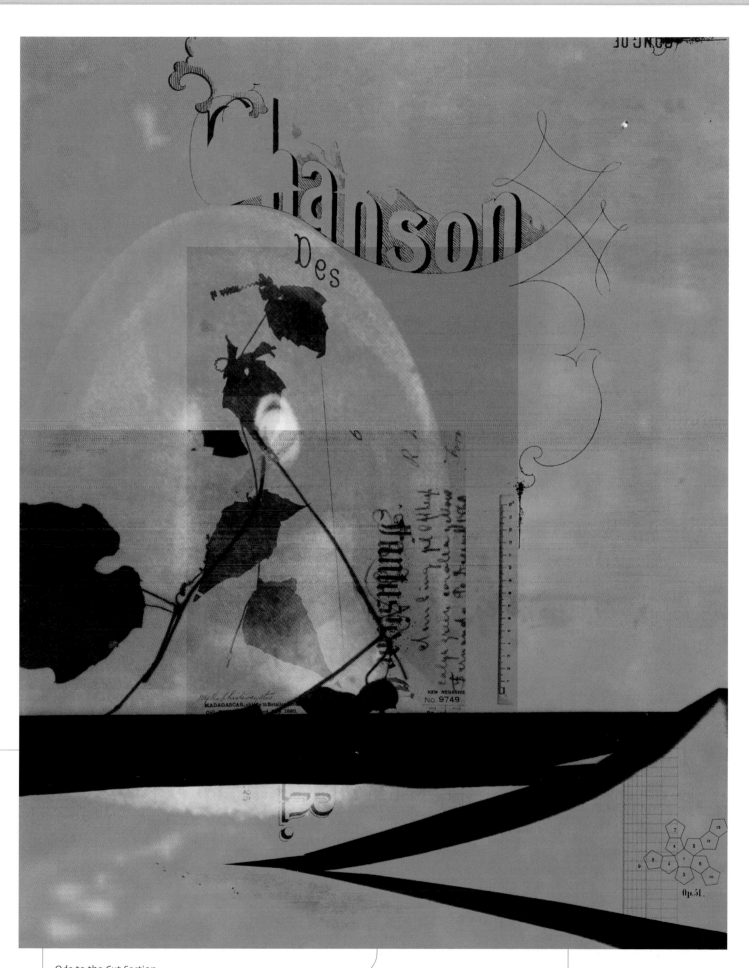

Ode to the Cut Section
Designer: Stephen Farrell
Client: IMGSRC 100, Tokyo
Concept: Inspired by a painting of Joseph Wright of Derby.

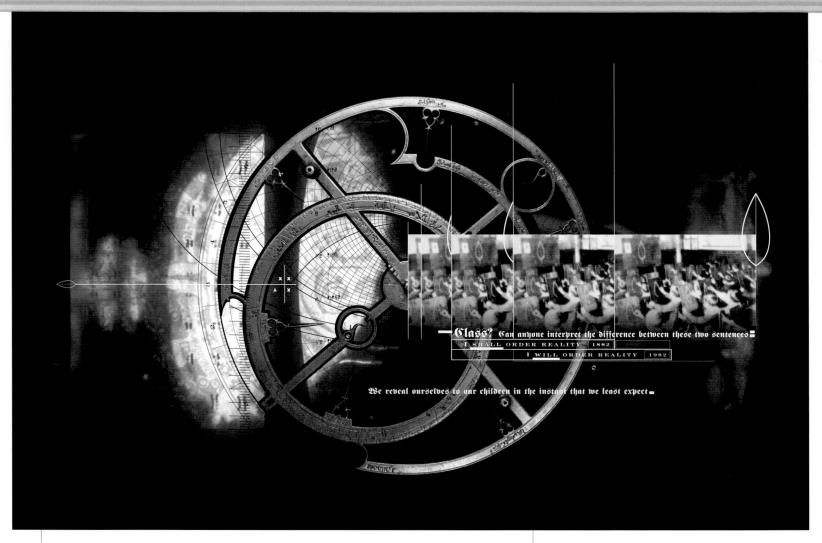

Within the image:

Class? Can anyone interpret the difference between these two sentences⊟

I SHALL ORDER REALITY | 1882 |

I WILL ORDER REALITY | 1982 |

We reveal ourselves to our children in the instant that we least expect⊟

TOC
Designer: Stephen Farrell
Writer: Steve Tomasula
Client: Émigré/magazine and font distributor
Concept: "TOC is a meditation on the construction of narrative and our conceptions of time. The tone is contemplative. A pregnant model wrestles with the foreignness of her identity on film and contradictions between regimented time constructs and her own lived time. To accentuate the nonlinearity of this character's 'lived time,' the panels are constructed as a closed loop folding back over itself to allow narrative elements to intersect and punctuate. TOC has been rescripted for a variety of media, including a performance for light and voice, a sculptural installation and an interactive version."

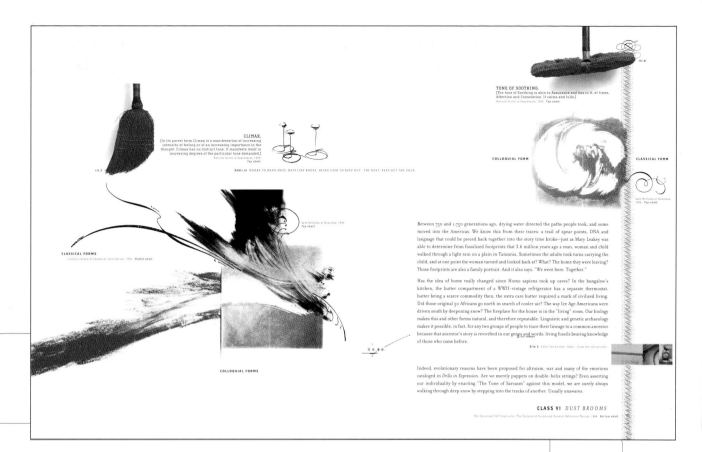

CLIMAX.
[In its purest form Climax is a manifestation of increasing intensity of feeling or of an increasing importance in the thought. Climax has no distinct tone. It manifests itself in increasing degrees of the particular tone demanded.]
Natural Drills in Expression. 1929. Top shelf.

EXHIBIT XX HOOKS TO HANG HATS. HATS LIKE ROOFS, BEING USED TO KEEP OUT THE HEAT. KEEP OUT THE COLD.

CLASSICAL FORMS
Lincoln Library of Essential Information. 1924. Middle shelf.

Safe Methods of Business. 1896. Top shelf.

COLLOQUIAL FORMS
Drills in Expression. 1929. Top shelf.

TONE OF SOOTHING.
[The tone of Soothing is akin to Assurance and has in it, at times, Affection and Consolation. It calms and lulls.]
Natural Drills in Expression. 1929. Top shelf.

COLLOQUIAL FORM **CLASSICAL FORM**

Safe Methods of Business. 1896. Top shelf.

Between 750 and 1,750 generations ago, drying water directed the paths people took, and some moved into the Americas. We know this from their traces: a trail of spear points, DNA and language that could be pieced back together into the story time broke—just as Mary Leakey was able to determine from fossilized footprints that 3.6 million years ago a man, woman and child walked through a light rain on a plain in Tanzania. Sometimes the adults took turns carrying the child, and at one point the woman turned and looked back at? What? The home they were leaving? Those footprints are also a family portrait. And it also says, "We were here. Together."

Has the idea of home really changed since Homo sapiens took up caves? In the bungalow's kitchen, the butter compartment of a WWII-vintage refrigerator has a separate thermostat, butter being a scarce commodity then, the extra care butter required a mark of civilized living. Did those original 50 Africans go north in search of cooler air? The way Ice Age Americans were driven south by deepening snow? The fireplace for the house is in the "living" room. Our biology makes this and other forms natural, and therefore repeatable. Linguistic and genetic archaeology makes it possible, in fact, for any two groups of people to trace their lineage to a common ancestor because that ancestor's story is revivified in our genes and words: living fossils bearing knowledge of those who came before.

Site 3 Enter the kitchen. Open . close the refrigerator.

Indeed, evolutionary reasons have been proposed for altruism, war and many of the emotions cataloged in *Drills in Expression*. Are we merely puppets on double-helix strings? Even asserting our individuality by enacting "The Tone of Sarcasm" against this model, we are surely always walking through deep snow by stepping into the tracks of another. Usually unawares.

CLASS VI *DUST BROOMS*
The Universal Self Instructor: The Epitome of Forms and General Reference Manual. 1884. Bottom shelf.

Visible Citizens
Designers: Stephen Farrell, Jiwon Son
Writer: Steve Tomasula
Client: Émigré/magazine and font distributor
Concept: "This piece—part essay, part installation—explores tangent points of lineage and connoisseurship between strokes made with a catalog of abandoned brooms and speaking/writing exercises from nineteenth-century courtesy books and shorthand materials," says Farrell. "A blend of cultural anthropology, philosophy, literature and linguistics, this work both acknowledges and challenges the impulse to classify and cast boundaries."

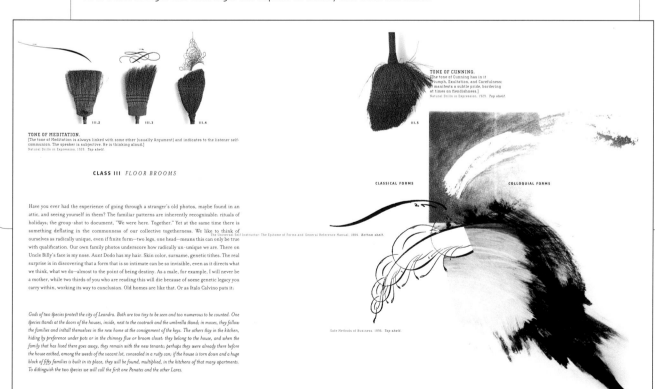

III.2 III.3 III.4

TONE OF MEDITATION.
[The tone of Meditation is always linked with some other (usually Argument) and indicates to the listener self-communion. The speaker is subjective. He is thinking aloud.]
Natural Drills in Expression. 1929. Top shelf.

CLASS III *FLOOR BROOMS*

Have you ever had the experience of going through a stranger's old photos, maybe found in an attic, and seeing yourself in them? The familiar patterns are inherently recognizable: rituals of holidays; the group-shot to document, "We were here. Together." Yet at the same time there is something deflating in the commonness of our collective togetherness. We like to think of ourselves as radically unique, even if finite form—two legs, one head—means this can only be true with qualification. Our own family photos underscore how radically un-unique we are. There on Uncle Billy's face is my nose. Aunt Dodo has my hair. Skin color, surname, genetic tithes. The real surprise is in discovering that a form that is so intimate can be so invisible, even as it directs what we think, what we do—almost to the point of being destiny. As a male, for example, I will never be a mother, while two thirds of you who are reading this will die because of some genetic legacy you carry within, working its way to conclusion. Old homes are like that. Or as Italo Calvino puts it:

Gods of two species protect the city of Leandra. Both are too tiny to be seen and too numerous to be counted. One species stands at the doors of the houses, inside, next to the coatrack and the umbrella stand; in moves, they follow the families and install themselves in the new home at the consignment of the keys. The others stay in the kitchen, hiding by preference under pots or in the chimney flue or broom closet: they belong to the house, and when the family that has lived there goes away, they remain with the new tenants; perhaps they were already there before the house existed, among the weeds of the vacant lot, concealed in a rusty can; if the house is torn down and a huge block of fifty families is built in its place, they will be found, multiplied, in the kitchens of that many apartments. To distinguish the two species we will call the first one Penates and the other Lares.

III.5

TONE OF CUNNING.
[The tone of Cunning has in it Triumph, Exultation, and Carefulness: it manifests a subtle pride, bordering at times on fiendishness.]
Natural Drills in Expression. 1929. Top shelf.

CLASSICAL FORMS **COLLOQUIAL FORMS**

Safe Methods of Business. 1896. Top shelf.

Sayuri Shoji moved to New York in 1991 to work as an independent art director and designer. Currently, she is working on various media such as advertising, editorials, books, product design and packaging, video and multimedia. Her honors include mentions in I.D. Magazine's Design Preview and Interactive Preview in 2000, the Graphis Design Annual and Poster Annual in 1999 and a FIFI Best Packaging Nomination, among others.

FLOAT
Designer: Sayuri Shoji
Client: Sterling Group, Sephora USA/candle, fragrance house
Concept: Shoji says the inspiration for this piece was creating "a modern lighting for your place. It floats in the package as well as it floats on the water."

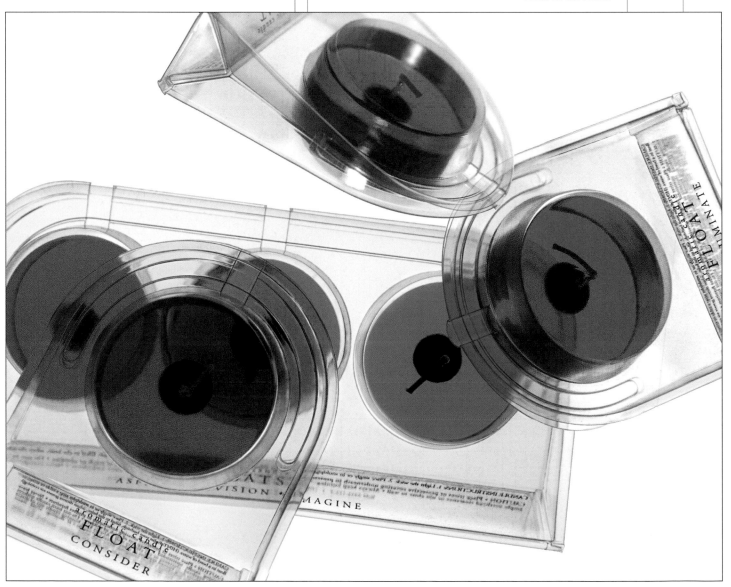

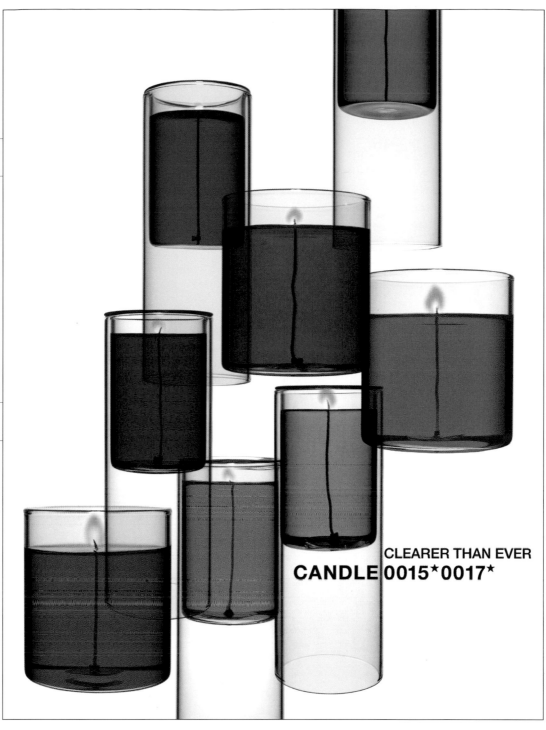

CANDLE 0015, 0017
Designer: Sayuri Shoji
Client: Sterling Group, Sephora USA/candle, fragrance house
Concept: "A modern, simple candle for home. The concept is 'You see nothing but colors,' achieved by all-clear packaging and also by the 'all-translucent' product. These candles happened to be the first solid translucent wax (not jelly) sold on the market."

CLEARER THAN EVER
CANDLE 0015*0017*

Pleats Please Web Site Promotional CD
Designer: Sayuri Shoji
Client: Issey Miyake, Inc./fashion house
Concept: "Cheerful, colorful, funlike Pleats Please products. Stripes express their unique 'pleats' in graphic format."

Cyclone Design is a Seattle-based, full-service creative firm with a national reputation for their award-winning branding, design (print and digital) and illustration for notable clients such as Visa, NFL, AT&T, Experience Music Project, Capitol Records, EMI Records, WOMAD USA, One Reel Productions, Seattle Repertory Theatre and Intiman Theatre.

After working as designers and art directors for various firms, principals Traci Daberko and Dennis Clouse joined forces in 1995 with their studio located in a Capitol Hill loft. The partners first met at the University of Nebraska; Clouse went on to get a master's degree in design communications from Pratt Institute in New York while Daberko headed West to Seattle.

Cyclone has received awards by almost every major design competition and publication. Projects include posters, corporate identity, packaging, signage, wine label design and retail store design, as well as providing illustration for various national magazines.

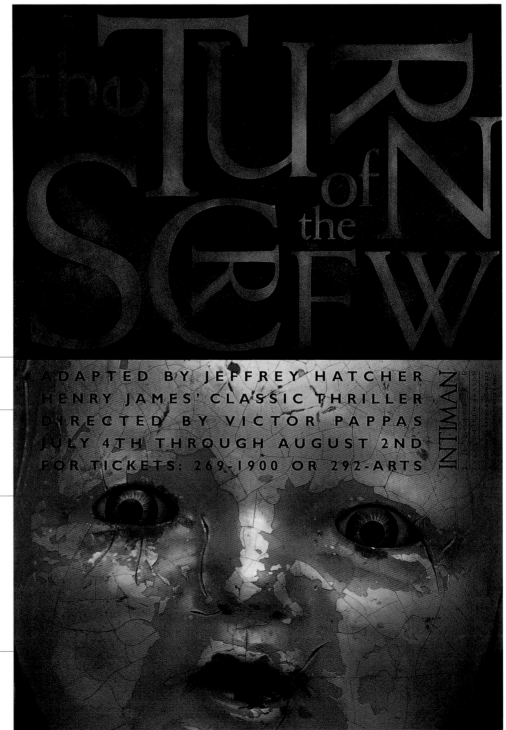

Turn of the Screw
Poster
Designers: Traci
Daberko, Dennis
Clouse
Client: Intiman
Theatre
Concept: "We wanted
to visually prepare the
audience for this
chilling story of lust
and possession. The
best way to express
'loss of innocence' was
through this powerful
image of a doll's face."

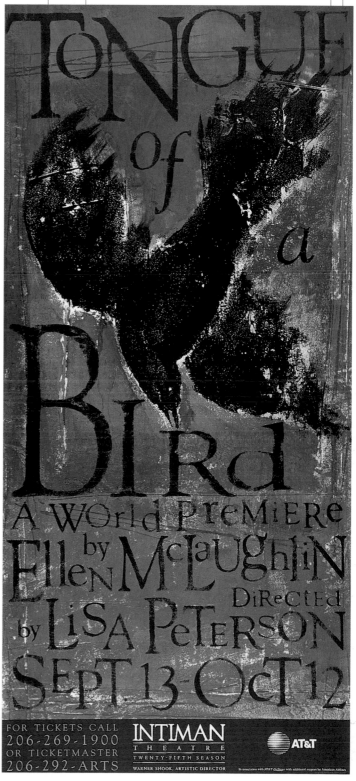

FUNNEL
TWISTER
TORNADO
TYPHOON
CYCLONE

WHEN WRITTEN IN CHINESE, THE WORD CRISIS IS COMPOSED OF TWO CHARACTERS. ONE REPRESENTS DANGER AND THE OTHER REPRESENTS OPPORTUNITY.

CYCLONE DESIGN & ILLUSTRATION · 206-223-7337

Funnel Promo Poster
Designers: Dennis Clouse, Traci Daberko
Client: Self
Concept: "We wanted to create a memorable self-promotion that burns 'Cyclone' into our client's or prospective client's brain."

Tongue of a Bird Poster
Designers: Traci Daberko, Dennis Clouse
Client: Intiman Theatre
Concept: "This play features a poetic story of a search-and-rescue pilot who hunts for an abducted girl while coming to terms with the loss of her own mother. We wanted to portray the rich, stunning imagery and symbolism revealed throughout the pilot's journey of finding one woman's lost child and her own lost childhood."

65

WOMAD USA 2000 Poster
Designers: Dennis Clouse,
Traci Daberko
Client: One Reel
Productions
Concept: WOMAD (World
of Music Arts and Dance) is
a three-day musical and
cultural celebration
representing a diverse
array of global talents
annually held in Seattle's
Marymoor Park.

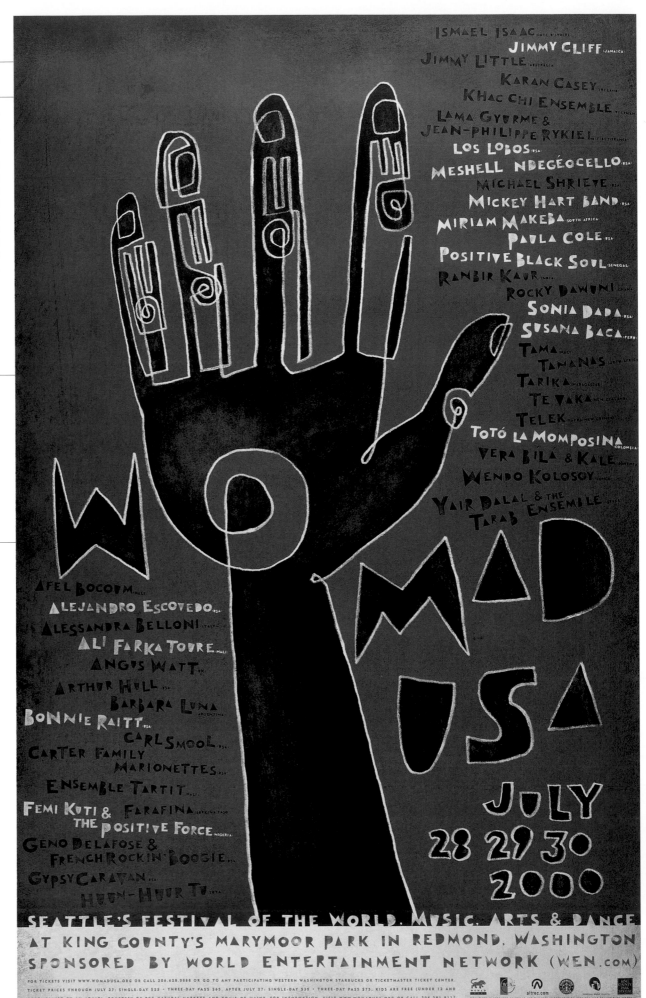

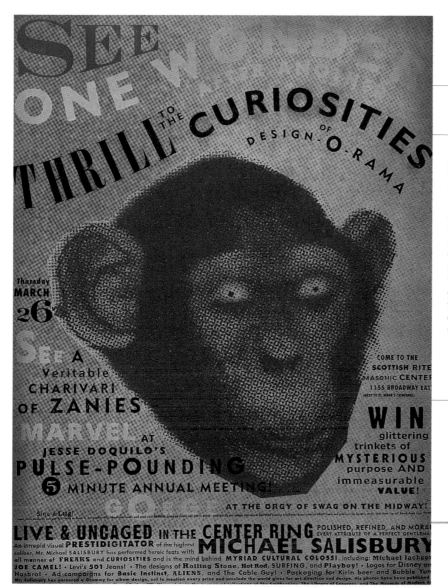

Design-O-Rama Poster
Designers: Dennis Clouse, Traci Daberko
Client: AIGA Seattle
Concept: "Design-O-Rama is an AIGA-sponsored event held for vendors and service providers to show off and display their latest papers, printing and technology to the design community. We gave it a circus look and feel to reflect the true experience of what it is like to attend."

Konstantin Poster
Designers: Traci Daberko, Dennis Clouse
Client: Printer's Devil Theatre
Concept: "This one-man show reveals a man's rambling thoughts about his demented obsessions. To capture this man's freakish ideas, we actually used the script as imagery."

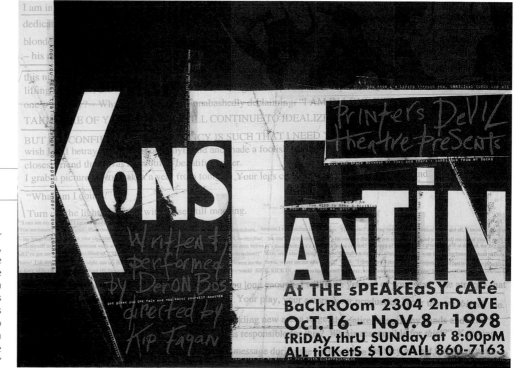

Darren Scott graduated from Salford University in Manchester with a bachelor of arts in design practice in 1996. In late 1996, he was installed as a designer and typographic consultant at McCann-Erickson Manchester, a member of the world's largest advertising network. Working for such a large company gave him the opportunity to experience all aspects of the industry and the benefits of dealing with international blue-chip clients.

Designing fonts was something Scott did as a student when he was asked to develop a typeface for FUSE 15 [Cities], which led to Berlin[er], his first digital font. His love affair with visible language developed from there.

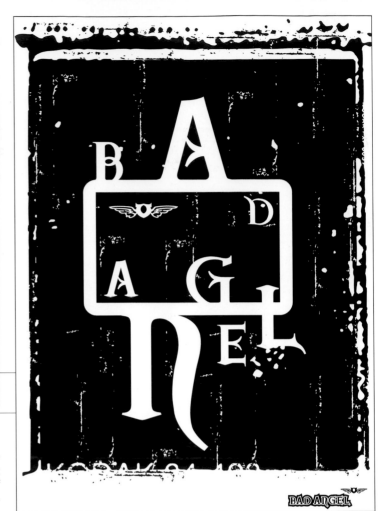

Bad Angel Poster
Designer: Darren Scott
Client: Self
Concept: Old Gothic letterforms.

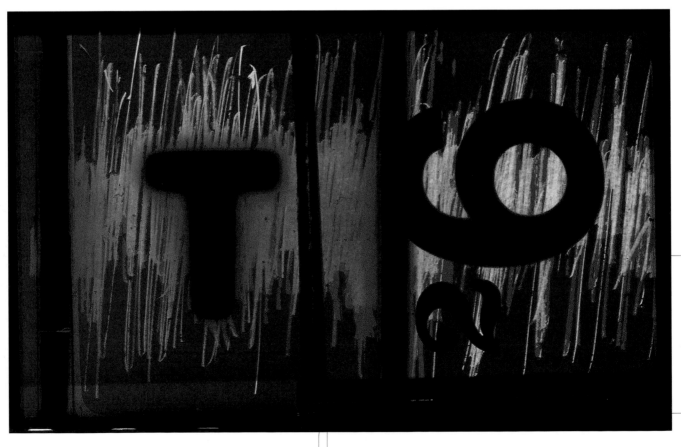

[T-26] Promotion
Designer: Darren Scott
Client: [T-26]/type foundry
Concept: "These were created by hand directly on the 35mm transparency and were kind of inspired by old Hitchcock movie titles," says Scott.

Type Movie Stills
Designer: Darren Scott
Client: Self
Concept: "These were also inspired by old Hitchcock movie titles."

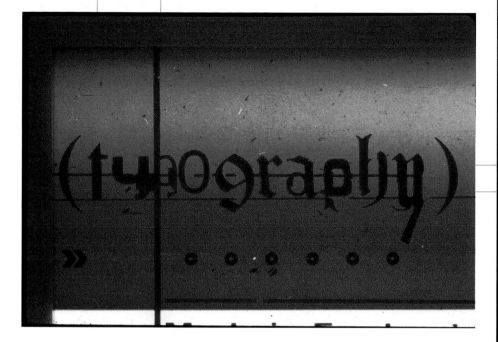

Aggregate
Typeface Poster
Designer: Darren
Scott
Client: Self
Concept: De Stijl vs.
Picasso. Total
deconstruction
reveals the
relationship between
a typeface and the
basic shapes used
within its
construction.

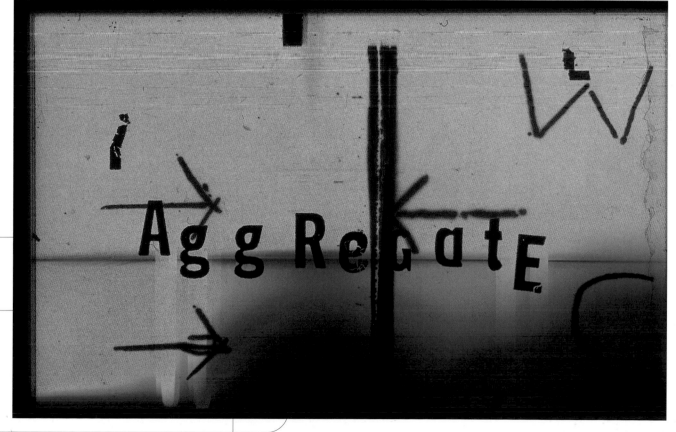

Aттik is a global ideas company that provides unique communication solutions for the world's most exciting and innovative brands. Established in 1986 by Simon Needham and James Sommerville, who set up shop in Sommerville's grandmother's attic, ATTIK has grown from a provincial agency in the north of England to a global player with over two hundred team members in five cities: Huddersfield, London, New York, San Francisco and Sydney.

Described by some as "mold-breakers," by others as "creative hand grenades" and by British Prime Minster Tony Blair as "ambassadors of New Britain," ATTIK has fired into the new millennium. Propelling a reputation for creativity into media beyond its initial print design offering, ATTIK has now become renowned as a visionary talent in corporate branding, animation, film directing, new product development, advertising, event management, interior design, direct marketing, broadcast design and interactive Web design.

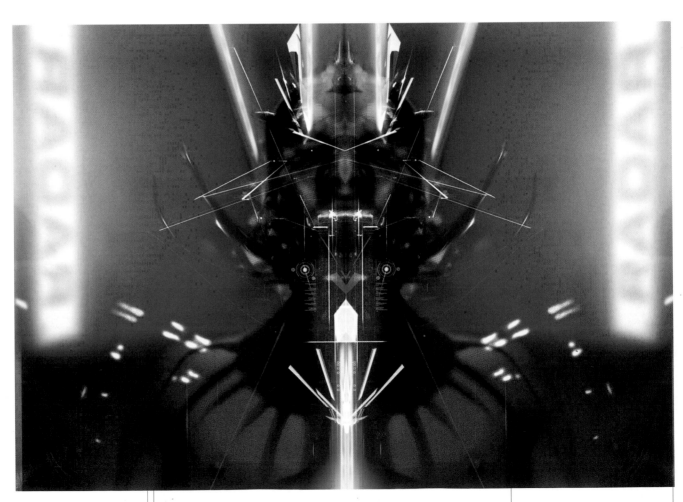

Surveillance
Designer: Aporva Baxi
Client: Self
Concept: Esposito describes this pieces as "the depiction of a frightening synthesis of humanity and technology as part of a twisted future reality."

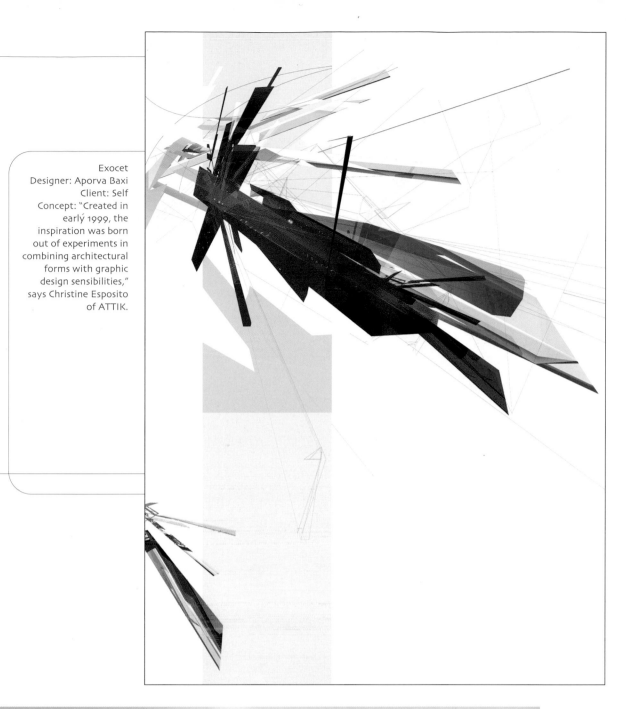

Exocet
Designer: Aporva Baxi
Client: Self
Concept: "Created in early 1999, the inspiration was born out of experiments in combining architectural forms with graphic design sensibilities," says Christine Esposito of ATTIK.

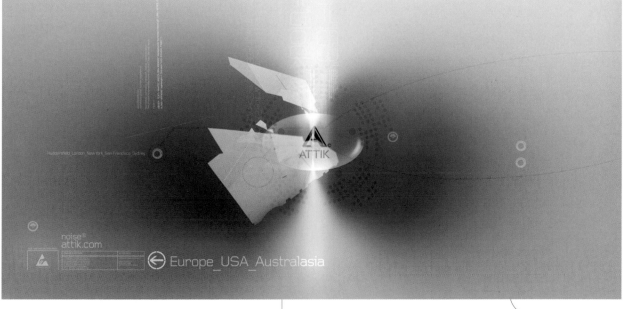

noise®
attik.com

Europe_USA_Australasia

Global
Designer: Aporva Baxi
Client: Self
Concept: "Created as a 7' × 4' promotional poster, it was inspired by the clinical elegance and symmetry of technology," explains Esposito. "It is an understated communication of ATTIK global."

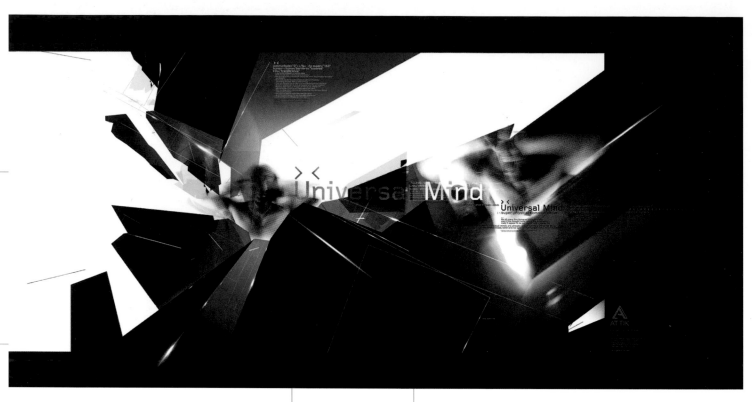

Universal Mind
Designer: Chris McCrae
Art director: Aporva Baxi
Client: Self
Concept: "Part of a larger research project about communication, Universal Mind is a metaphorical exploration of communication through telepathy," says Esposito.

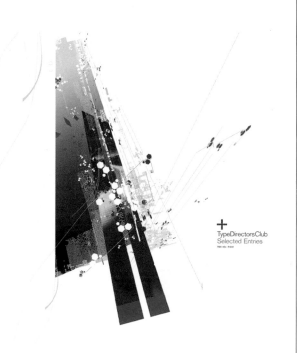

Typographic21
Designers: Michael Spoljaric,
John O'Callaghan
Design director: Paul S. Driver
Creative director: Aporva Baxi
Artworker: David Rothblatt
Client: Type Directors Club
Concept: "It was always intended that the book would be a team effort involving submissions from a variety of designers with ATTIK, therefore the use of a theme would help maintain a certain amount of consistency," says the ATTIK creative team. "We took our influences from a number of internal photo shoots and a variety of elements, including medical packaging. This explains the use of red throughout the book and elements such as the red cross. Visually it was our challenge to create design styles that progressed forward. We wanted to surprise the reader with each turn of the page. The title pages would differ in style. These were always going to be the most intense spreads through careful layering and use of color."

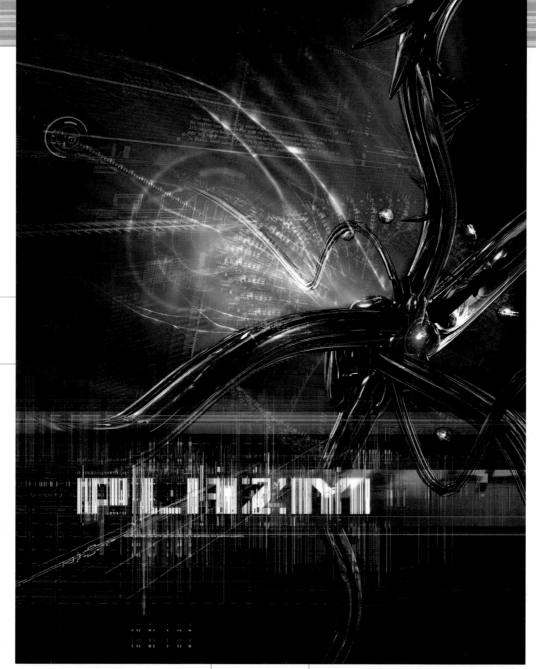

Plazm Magazine Design
Designers: Simon
Dixon, Monica Perez,
Vladimir Lubel
Creative director:
Simon Dixon
Clients: Plazm
Magazine, ATTIK
Concept: "The theme of
the magazine was
gloss—both culturally
and conceptually," say
the designers. "The
poster and magazine
cover created reflect
the idea that
communication is a
gloss on the surface of
human consciousness."

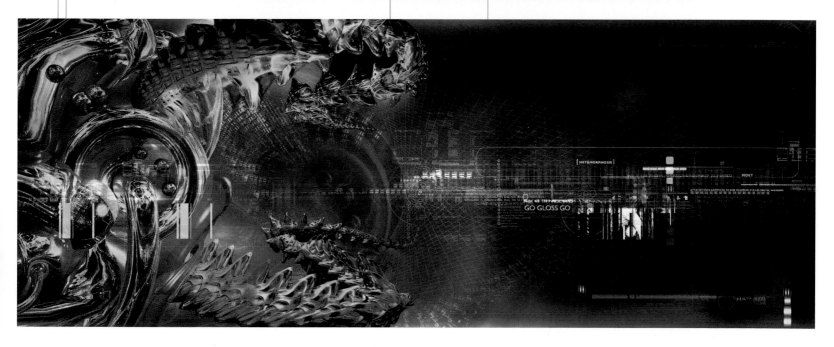

Cranbrook's program supports the solitary path of the creative individual. They believe first and foremost in "getting it right with oneself." At Cranbrook, the use of time is largely self-constructed. Courses of study evolve from each individual. Everyone anticipates a high level of productivity and everyone generously contributes. They live and work together and are energized by mutual accomplishment.

Nothing Is as It Appears
Designer: Paul Schneider
Art director: Laurie Haycock Makela
Client: Self
Concept: Makela says the inspiration for this piece was "Scott's death."

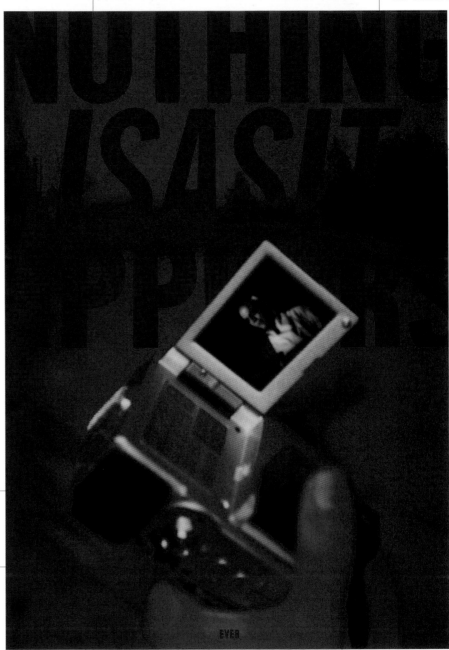

Unkross Video Stills
Designer: Jeff Miller
Client: Self
Concept: "Unkross Stars is the official name of the video I produced with manipulating type and form both by hand and electronically," says Miller. "The typography was designed to push against the two-dimensional into a three-dimensional object."

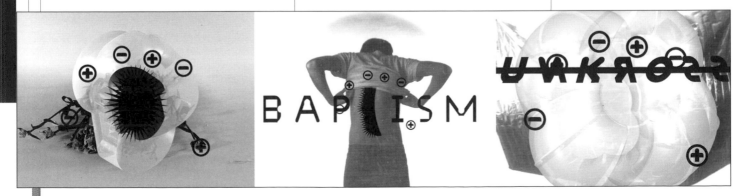

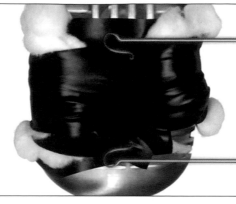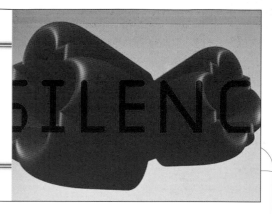

Amplify Silence Video Stills
Designer: Jeff Miller
Client: Self
"Amplify Silence is the name of this video originally projected against a 15' × 12' wall in a room of the same size. The divine excess of Latin American architecture was placed in an electronic environment, and when viewed as a projection, the forms became large silent masses whose visual and audio elements nearly suffocate the audience."

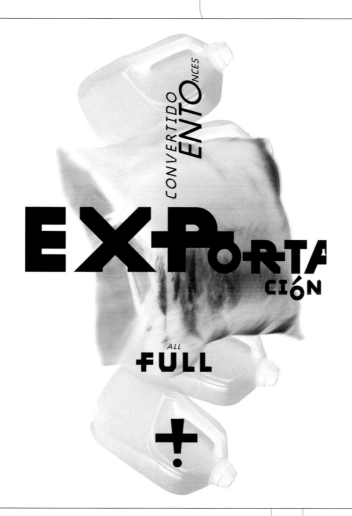

Maternal Electricity
Designer: Jeff Miller
Client: Self
Concept: "One of a series of posters, this particular one is responding to the writing of Che Guevara on guerilla warfare. The Spanish language was used in honor of the author's Latin tongue and his apostolic fervor toward his America."

Inflated Hair
Designer: Jeff Miller
Client: Self
Concept: "A portrait—or non-portrait—of Mao was produced by photographing bicycle inner tubes and reconfiguring the image into the shape of his hair."

Five years ago, Joyce Hesselberth and David Plunkert decided to merge their freelance businesses into one graphic design and illustration studio. Half a decade later, their dream of an idea-driven company has been realized in Spur. Now with six staff members, Spur has won numerous awards from industry trade journals and has their work displayed in various museums.

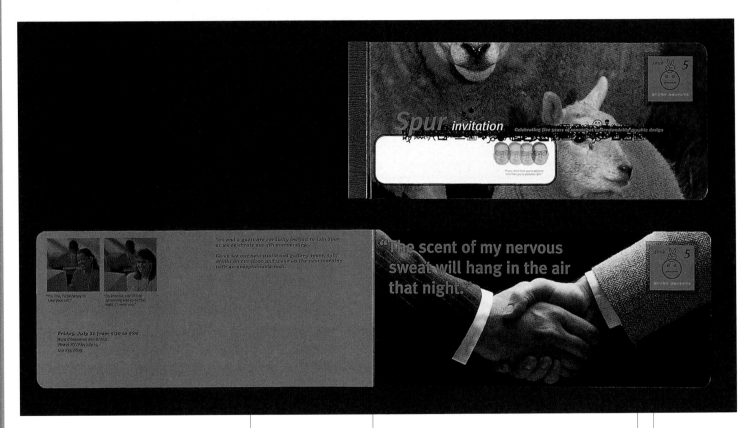

Blunt Objects Invitation
Designer: David Plunkert
Photographers: Joyce Hesselberth, various
Client: Self
Concept: According to Plunkert, this invitation was all about "combining the worst copyright-free photography with in-your-face copy" or "to be as blunt as possible."

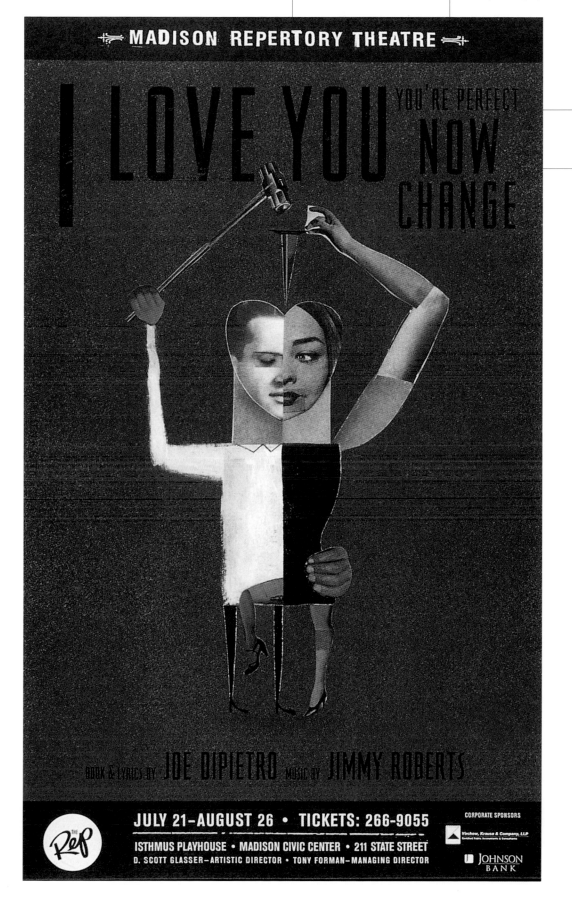

I Love You Poster
Designer: David Plunkert
Art director: Chad Bollenbach of Lindsay, Stone & Briggs
Client: Madison Repertory Theatre
Concept: The play I Love You, You're Perfect, Now Change.

Spur Web Poster
Designer: Joyce Hesselberth
Art director: David Plunkert
Photographer: Mike Northrup
Client: Self
Concept: "The industrial nature of our work is reflected in the barrel device worn by our innocuous model Joe," says Plunkert.

Noises Off
Poster
Designer: David Plunkert
Art director: Chad Bollenbach of Lindsay, Stone & Briggs
Client: Madison Repertory Theatre
Concept: The play Noises Off by Michael Frayn.

M A P

OUT OF ORDER AGAIN

Exhibition Benefit Party and Silent Auction

Saturday, May 3, 1997 @ 8:00pm to midnight. Festive attire

art live music hors d'oeuvres cash bar
RSVP by April 26. Please use enclosed RSVP Card

Music by The Swinging Swami's and other special guests

$25 per person. To benefit Maryland Art Place's exhibitions & programs

MAP, 218 W. Saratoga Street, Baltimore, MD 21201

Parking @ Arrow Parking, 229 W. Saratoga ST (Across the street from MAP)

For information call 410 962 8565

Map Invitation
Designer: David Plunkert
Client: Maryland Art Place/art gallery
Concept: "Oroboros (the snake swallowing its own tail) is used to depict a salon-style art show benefiting Maryland Art Place," explains Plunkert.

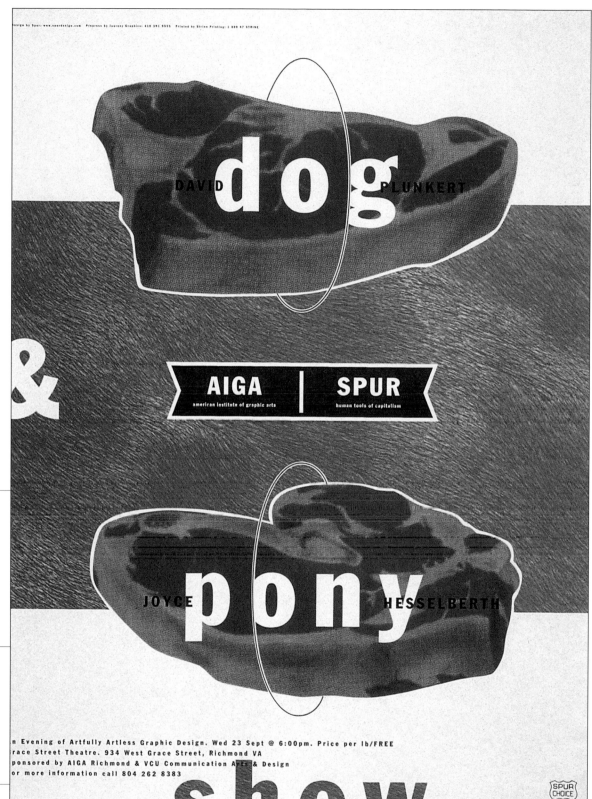

Dog + Pony Show Poster
Designer: David Plunkert
Client: AIGA
Concept: "AIGA poster promoting exhibition through the use of meat labeled 'dog' and 'pony' on a layer of skin."

After earning a bachelor of fine arts in graphic design from Iowa State University in 1995, Jason Schulte worked for Charles S. Anderson Design Company in Minneapolis until August 1999. He then joined Vehicle, a San Francisco-based multimedia design firm.

Schulte's work has been nationally and internationally recognized by American Center for Design, American Institute of Graphic Arts, Communication Arts, Graphis, New York Art Directors Club and Tokyo Type Director's Club, among others. He was named one of the top twenty visual artists under age thirty in Print magazine's 2000 International Visual Artists Review.

Schulte has worked on projects for French Paper Company, Nike, IBM, American Institute of Astronautics and Aeronautics, Americans for Radio Diversity, Isuzu, Pepsi-Cola Company, Target, Dockers, Red Herring Magazine, Chums and Rodale Incorporated.

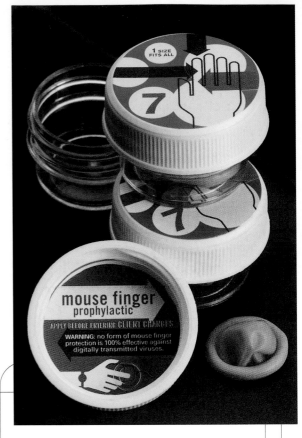

French Annual Report Survival Kit
Designer: Jason Schulte
Art director: Charles S. Anderson
Writer: Lisa Pemrick
Client: French Paper Company/uncoated text and cover papers
Concept: "The French Annual Report Survival Kit was sent out to designers to help them make it through rounds of client approvals and late nights associated with designing an annual report," says Schulte. He adds, "The response we received was that we should have sent more martinis."

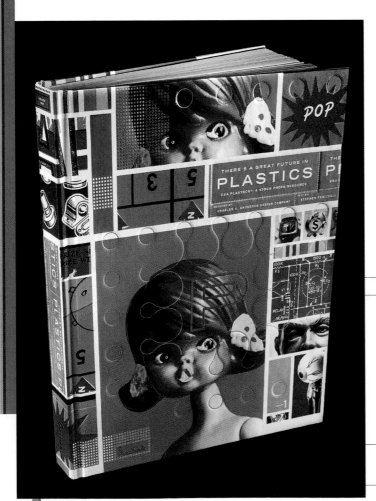

CSA Plastock Catalog
Designers: Jason Schulte, Todd Piper-Hauswirth, Charles S. Anderson
Art director: Charles S. Anderson
Client: CSA Images/stock imagery
Concept: CSA Plastock is a stock and assignment resource featuring photographs of plastic objects. Using this information, says Schulte, the designers created a design demonstrating how we are living in the 'Plastic Age.' "

French Stack-O-Packs
Designer: Jason Schulte
Art director: Charles S. Anderson
Writer: Lisa Pemrick
Client: French Paper Company/uncoated
text and cover papers
Concept: French Paper's new line of
heavyweight papers, Muscletone, which is
ideal for packaging applications.

David Bradshaw, David Breen and Joseph Thomas started Push in 1994. They have become known as designers committed to creating challenging works that engage the audience through inventive concepts juxtaposing strong color against hand-drawn elements. These are enhanced by their playful, energetic image-making and photography skills. Over the past four years, they have worked for a variety of music, media and publishing companies. Clients include Sony, Emap On Air, Orion Books, Granda Sky Broadcasting, MTV, VH1, Virgin Interactive, Ebury Press and the British Film Institute, among others.

Emap/Kiss FM/Magic FM Promotional Mailer
Designer: David Bradshaw
Client: Emap/Radio broadcaster
Concept: "We were commissioned the produce an exciting mailer that would chart the historical development of two of Emap's London radio stations (Kiss FM and Magic FM) and celebrate their enormous success," says Bradshaw. "Push responded by creating a map, the cover of which acts as a 'guide to the two-year success story.' We silkscreen the corporate colors of each station onto actual pre-printed maps. A good format for getting a lot of exciting visual information into a small manageable packet."

Push Brochure
Designer: Joseph Thomas
Photographers: Lee Funnel, Tony Gibson
Client: Self
Concept: Clothes washing liquid re-fills.
"The piece should intrigue and engage the viewer," says Thomas. "The viewer's perception should change as the piece unfolds."

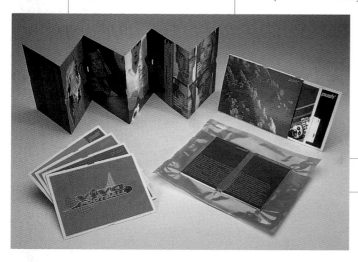

Animated Encounters Festival Poster
Designer: David Bradshaw
Client: Animated Encounters/Promotion for Bristol
Concept: "A set of comedy chattering teeth meeting a Jack-in-the-Box exploding from a hand-drawn 'other world' equals an animated encounter," explains Bradshaw. "The poster creates an arresting central image that simultaneously reflects the wide range of animation techniques used in the films shown at the festival. Hence the combination of three-dimensional arms, hand-drawn skyscape, photographic characters and line-art background. The dangling logos were a tongue-in-cheek reference to the delicate relationship between organizers and sponsors-who is pulling the strings?"

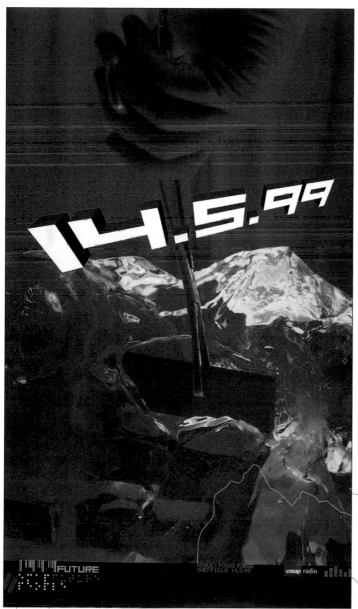

Emap Radio Awards Publicity
Designer: David Breen
Photographer: Lee Funnel
Client: Emap/Radio broadcaster
Concept: "The theme was 'future,'" says Breen. "Imagery and text was inspired by cryogenics. The date of the awards ceremony is the focal point, and is being extracted from the ice."

Stefan Sagmeister, a native of Austria, received his master of fine arts in graphic design from the University of Applied Arts in Vienna and, as a Fulbright scholar, a master's degree from Pratt Institute in New York. Following stints at M & Co. in New York and as creative director at the Hong Kong office of the advertising agency Leo Burnett, Sagmeister formed the New York-based Sagmeister, Inc., in 1993. He designed graphics and packaging for the Rolling Stones, David Byrne, Lou Reed, Aerosmith and Pat Metheny. His work has received four Grammy nominations and has won many international design awards.

Frank's Disaster Art
Designer: Stefan Sagmeister
Client: Thomas Sandri/Engineering for art
Concept: "Frank's Disaster Art is a small company in Vienna manufacturing beautiful automated machines. One of their products is a vending machine. The customer pays two dollars, a curtain opens, two mechanical arms grab a plastic model of the Stephan's Cathedral. Then the arms break off the spire and throw it down a chute. The customer gets a broken Stephan's Cathedral. So the stationery, logically, had to feature a cut in half aardvark."

Anni Kuan Brochure
Designers: H. Karlsson, Martin Woodtli
Art director: Stefan Sagmeister
Photographer: Tom Schierlitz
Client: Anni Kuan Design/Fashion design
Concept: Sagmeister says that for this brochure project celebrating New York laundromats for New York designer Anni Kuan, "We really only had the budget to print a postcard. We could do the entire run on newsprint for under five hundred dollars. We then bought wire hangers at two cents each and corrugated boards at twelve cents a piece. We got a shrink wrap machine for five hundred dollars and the client hired a student to put it all together."

PREVIOUS SPREAD:
RED TOP WITH FEATHER IN MATTE JERSEY 100% RAYON
RED TANGO SKIRT WITH FEATHER IN MATTE JERSEY 100% RAYON
THIS SPREAD:
HEATHER GREY QUILTED COAT IN STRETCH WOOL
88% WOOL 16% POLYAMIDE 4% LYCRA
FAKE FUR SCARF 100% ACRYLIC

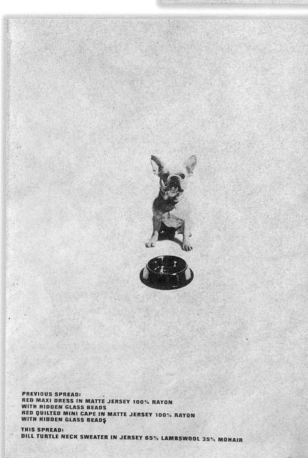

PREVIOUS SPREAD:
RED MAXI DRESS IN MATTE JERSEY 100% RAYON
WITH HIDDEN GLASS BEADS
RED QUILTED MINI CAPE IN MATTE JERSEY 100% RAYON
WITH HIDDEN GLASS BEADS
THIS SPREAD:
DILL TURTLE NECK SWEATER IN JERSEY 65% LAMBSWOOL 35% MOHAIR

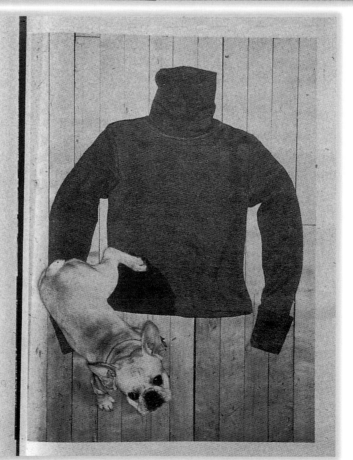

Pro-Pain CD
Designers: Stefan Sagmeister, Veronica Oh
Client: Energy Records/Record company
Concept: "This is a CD cover for Pro-Pain, a hard core band in New York. The music is at first hearing tough and disturbing, but if you listen closely turns out to be quite beautiful. The same is true for the front cover. It was shot in a morgue. The woman dled in her sleep and her body was opened to determine the cause of her death. No retouching has been done. The booklet photography was found in the police collection of the Municipal Archives in New York."

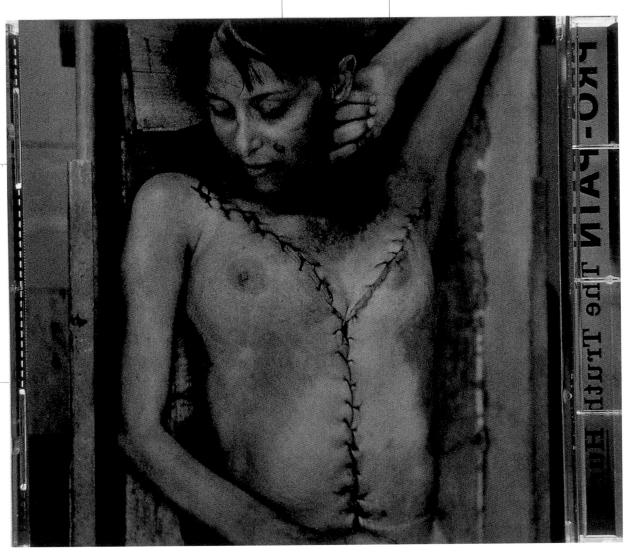

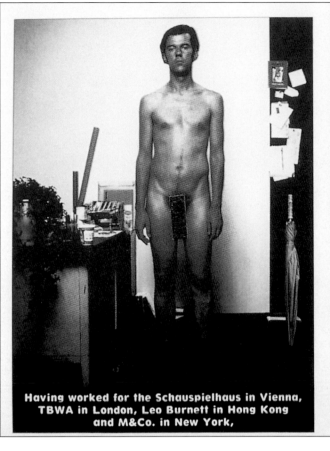

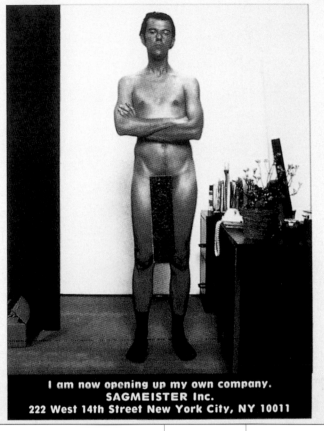

Having worked for the Schauspielhaus in Vienna, TBWA in London, Leo Burnett in Hong Kong and M&Co. in New York,

**I am now opening up my own company.
SAGMEISTER Inc.
222 West 14th Street New York City, NY 10011**

Studio Opening Card
Designer: Eric Zim
Art director: Stefan Sagmeister
Photographer: Tom Schierlitz
Client: Self
Concept: "I sent out this card with removable tape over the private parts. Copy underneath the first picture reads: 'Having worked for the Schauspielhaus in Vienna, TBWA in London, Leo Burnett in Hong Kong and M & Co. in New York,' and the final picture reads, 'I am now opening up my own company. Sagmeister Inc.'"

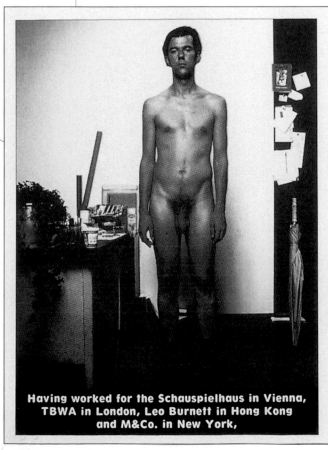

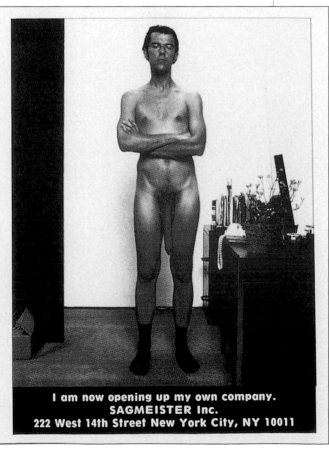

Having worked for the Schauspielhaus in Vienna, TBWA in London, Leo Burnett in Hong Kong and M&Co. in New York,

**I am now opening up my own company.
SAGMEISTER Inc.
222 West 14th Street New York City, NY 10011**

Anselm Dastner started BOYZand-GIRLS with Nina Schlechtriem, which led to co-founding the magazine Flyer in 1998. Flyer has been dubbed "the bible of night life." Before starting BOYZandGIRLS, Dastner grew up in Freiburg, Germany, in the Black Forest. At the age of 20, he worked as a photography assistant and then, encouraged by sculpture teacher Jim Gallagher, whom he met on a 1986 exchange program to Lancaster, Pennsylvania, he studied arts in Philadelphia and later New York.

Combining the German techno trend, the New York night life, and the strong inspiration from the music, Dastner began making party flyers for the clubs. Before founding BOYZand-GIRLS, Dastner worked with the Konkrete Jungle.

Planet Electrica "Protection"
Designer: Anselm Dastner
Client: Rampage Music/Record label
Concept: "The first one in a series called 'Planet Electrica,' this two-CD compilation features previously little known tracks of famous electronic artists. Since this compilation is in part made possible through the ELF (Earth Love Fund) to protect the environment from natural disasters, I thought that the two CDs could be used as radar screens covering a hurricane. Radar feels sort-of-analog, just as the equipment that electronic tracks are often made with originality. The radio waves cover the Earth like a protective net."

Stamina, Club Flyer
Designer: Anselm Dastner
Photographer: Nina Schlechtriem
Client: Hands on Deck Promotions of Brooklyn/DJ booking agency
Concept: "We turned a picture of a video joystick on its said," says Dastner. "Now it looks like a dimly lit lounge with neon lights."

Flyer Covers
Designer: Anselm Dastner
Client: Flyer NYC/Portable night club info guide for New York; pop-culture magazine
Concept: "Bootlegs of popular culture icons have been used for visuals in the dance music scene just like audio artists use samples. It is Flyer's recognition to use the persiflage of products to portray American pop culture."

Michael Robinson and Noel Honig created Toupee in 1996 to explore the exciting crossovers between film, graphic design, computer animation and photography. Collaborating with some of downtown New York's most charismatic artists, filmmakers, dancers and musicians, Toupee produces work emphasizing unusual movement, striking colors and bold design. Since its inception, Toupee has completed successful film showings at the 1998 Computerworld/Smithsonian Awards, the 1998 RESFEST tour, the first annual Ret.Inevitable film festival (NTC), the Whitney Biennial Performance Series, the AIGA's "Fresh Dialogue" conference, etc. Toupee has done design and photography for Atlantic Records, Little Brown Publishing, the Walker Arts Center and more.

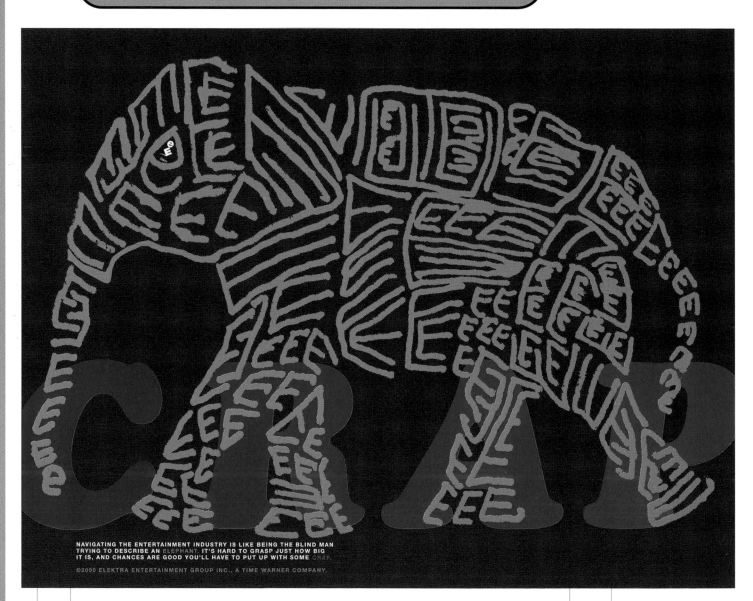

NAVIGATING THE ENTERTAINMENT INDUSTRY IS LIKE BEING THE BLIND MAN TRYING TO DESCRIBE AN ELEPHANT. IT'S HARD TO GRASP JUST HOW BIG IT IS, AND CHANCES ARE GOOD YOU'LL HAVE TO PUT UP WITH SOME CRAP.

©2000 ELEKTRA ENTERTAINMENT GROUP INC., A TIME WARNER COMPANY.

Elektra Entertainment Group MTV Video Awards Ad
Designer: Michael Robinson
Client: Elektra Entertainment Group/record label
Concept: "Elektra Records came to us with the copy and needed the ad built around it," says Robinson.
"I thought it would be amusing to reference Chris Offilli, the British painter whose painting of the Virgin Mary with elephant dung on it caused a huge First Amendment scandal. The painting is part of Charles Saatchi's collection that was on display at the Brooklyn Museum. I thought it would be funny to open the book up and all you saw was elephant crap. The joke continues visually because the elephant really isn't an elephant, but rather an impression of one."

Capricorn Records New Years Present Using the Music of Their Band, Deathray
Designer: Michael Robinson
Client: Capricorn Records/record label
Concept: "The concept for the CD was about letting go of things so one could freely embrace the future."

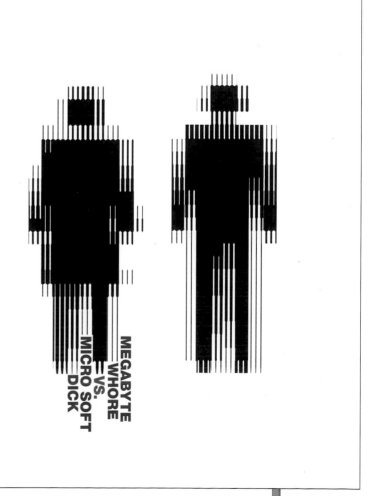

Megabyte Whore vs. Micro Soft Dick
Designer: Michael Robinson
Art directors: Michael Robinson, Noel Honig
Client: Team Somnambulist/fashion and product design
Concept: "The inspiration came from us hanging out in a cafe in London inebriated looking at Time Out magazine with Meg Ryan on the cover. We started to draw on top of her and...."

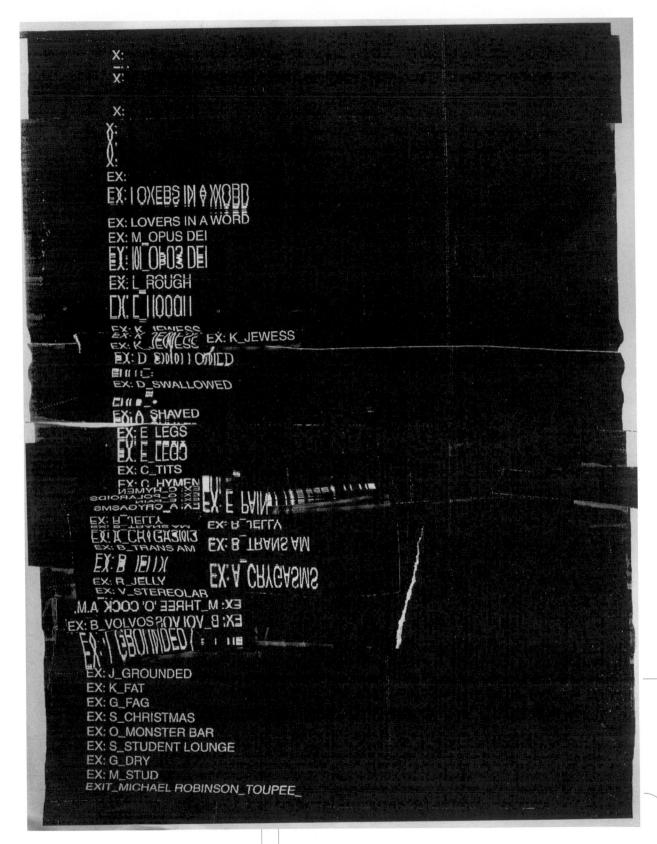

EX: I LOVERS IN A WORD
EX: LOVERS IN A WORD
EX: M_OPUS DEI
EX: M_OPUS DEI
EX: L_ROUGH
EX: L_1000II
EX: K_JEWESS
EX: K_JEWESS EX: K_JEWESS
EX: D_SWALLOWED
EX: D_SWALLOWED
EX: A_SHAVED
EX: A_SHAVED
EX: E_LEGS
EX: E_LEGS
EX: C_TITS
EX: O_HYMEN
EX: B_JELLY
EX: X_ORGASMS
EX: B_TRANS AM
EX: B_JELLY
EX: R_JELLY
EX: V_STEREOLAB
EX: M_THREE 'O' COCK A.M.
EX: B_VOLVOS
EX: J_GROUNDED
EX: J_GROUNDED
EX: K_FAT
EX: G_FAG
EX: S_CHRISTMAS
EX: O_MONSTER BAR
EX: S_STUDENT LOUNGE
EX: G_DRY
EX: M_STUD
EXIT_MICHAEL ROBINSON_TOUPEE_

e"X": lovers in a word
Designer: Michael Robinson
Client: Fakakte/Annual magazine
Concept: "Fakakte is a magazine that comes out annually at New Year's with
every page being done by a different type of artist. Contributors are cartoonists,
painters, architects, musicians, writers, poets, etc. The theme of this issue was the
alphabet in relation to New York City, and I got the letter X to work with. With X
being the variable of change, I free-associated the first word that came to mind in
relation to each girlfriend I've been with. The variable became what makes them
all so different from each other. The words are actually all trigger points to much
larger stories and jokes."

Atlantic Records CMJ Ad
Designer: Michael Robinson
Client: Atlantic Records/record label
Concept: "The Richard Avedon photograph
of William Burroughs and David Bowie if
viewed after watching Velvet Goldmine
has an odd effect on you."

Virgos Merlot, Signs of a Vacant Soul Album Art
Designer: Michael Robinson
Client: Atlantic Records/record label
Concept: "The concept of David Lynch's Lost Highway vs. the sensation
of careening out of control at a high velocity vs. the sight of a menacing
kind of beauty. The title, Signs of a Vacant Soul, made me think of the body
as a vessel and what one looks like as an empty vessel. The idea was taken
further by literally showing you the soul piece by piece."

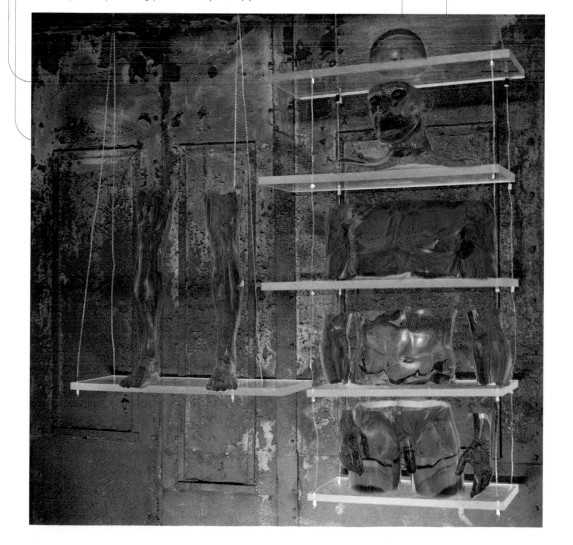

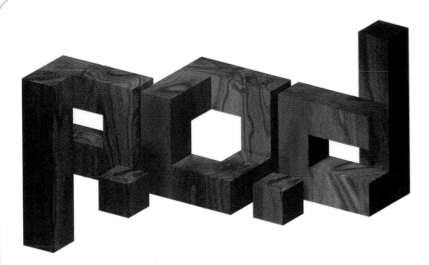

P.O.D. (Payable on Death) Photo and Logo
Designer: Michael Robinson
Photographer: Chapman Baehler
Photograph retoucher: Eric Altenberger
Client: Atlantic Records/Record label
Concept: "I had spent the morning with the band looking at surrealist art for their record package. They were perfectly willing to have their image toyed with, so I had a day before the shoot to conceptualize. Chapman and I scouted locations that would feel more like a rough neighborhood in San Diego where the band originates. When I jumped into this train car, the idea hit me to fill it with them. I called my retoucher in New York from a cell phone and mapped out how to set the shot up. He composited forty photos together to make one image. The logo type was created by my friend Mystik and digitized by Rob Eberhardt. I love to have an idea and get many strong talents together to play off each other."

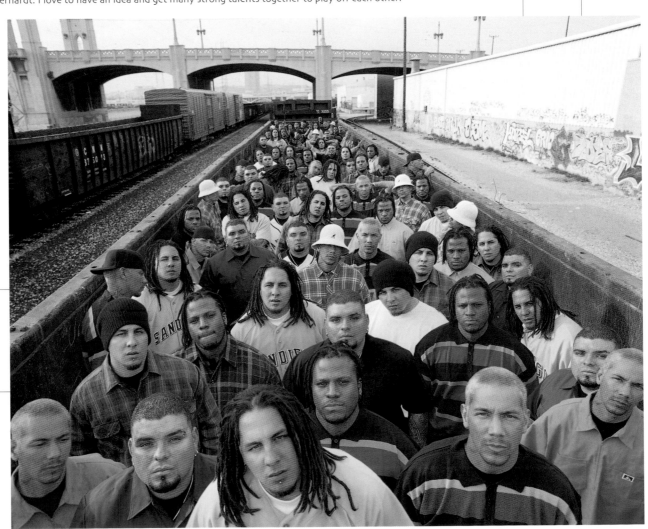

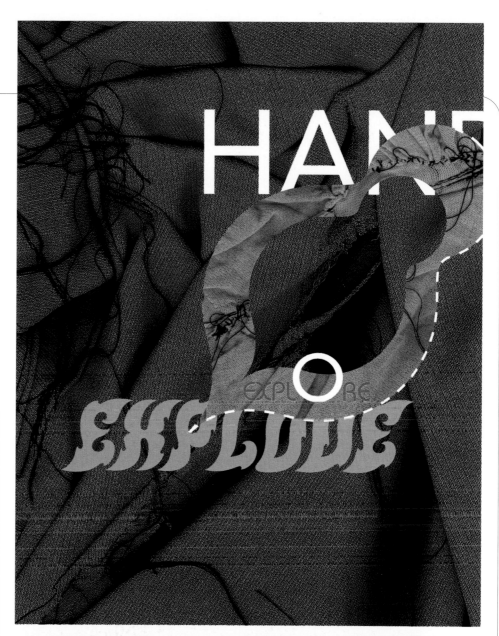

HAND

EXPLORE

EHFLUDE

Ann Hitchcock/Space Projekt,
San Francisco
Designer: Michael Robinson
Client: Ann Hitchcock/
fashion designer
Concept: "The concept for the
installation was an exquisite corpse
between Ann's clothing on
mannequins, my business partner Noel
Honlg's film and my wallpaper. Her
clothing is all created by her so each
garment is totally original. We all
worked independently of each other in
order to fully embrace the chaos. I
purposely made images that don't link
because even if she makes two dresses
in the same style or fabric, they are
totally unique from each other. This
way the viewer would experience the
various emotions her clothing brings
out in me and see how each garment is
so personal."

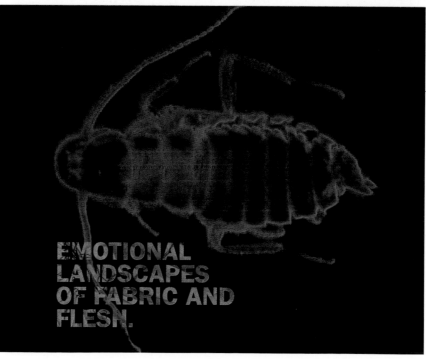

EMOTIONAL
LANDSCAPES
OF FABRIC AND
FLESH.

Ride is the source for a variety of network information. Their problem-solving is a full study in balanced solution. The client-studio relationship is an important part of their creative process. Their aesthetic is a combination of working and experimenting with ideas. Keeping an organic presence in the work is one of the strong points allowing it to have a life of its own. These approaches in design and process have allowed them to cross over effectively into all forms of media, delivering well-balanced design and visuals.

Life +
Designer: Scott Clum
Photographers: Trevor Craves, Scott Clum
Client: Narrow Snowboards/
snowboard manufacturer
Concept: Clum describes this piece as "taking the language and culture of snowboarding and turning it into a visual language —raw, energetic, young, with visual form."

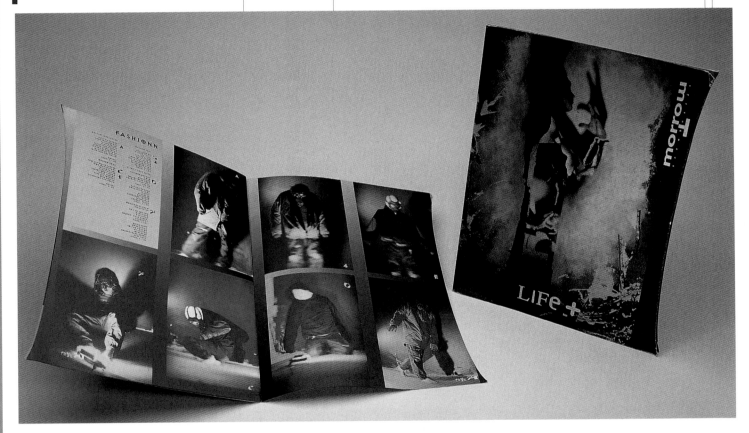

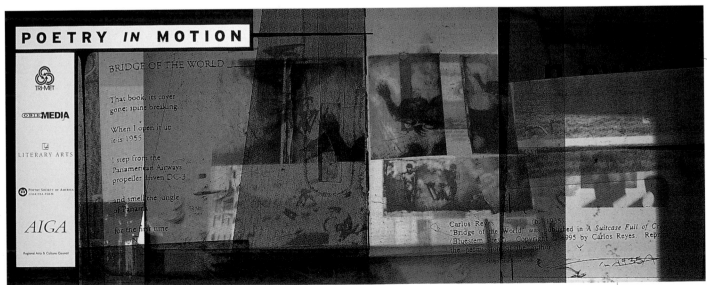

Poetry in Motion
Designer: Scott Clum
Client: AIGA of Portland, Oregon/Graphic artists' group
Concept: Color film negatives.

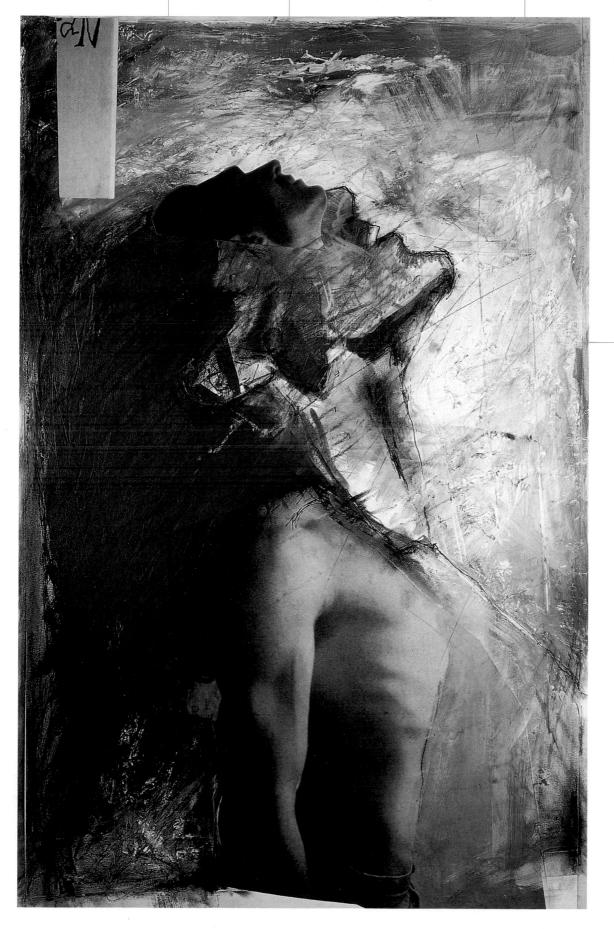

Portrait of Gavin Wilson and Scott Clum
Designer: Scott Clum
Client: Self
Concept: Lifelong relationship.

Blur Magazine
Designer: Scott Clum
Illustrator: Matt Mahurin
Client: Blur
Concept: According to Clum, "Blur was a collaboration between artists, creatively handled by myself and arranged by my partner Gavin Wilson. The design was freeform and experimental. Why did we do it? Blur was able to show other sides of artists' work and personalities that bigger magazines wouldn't dare print."

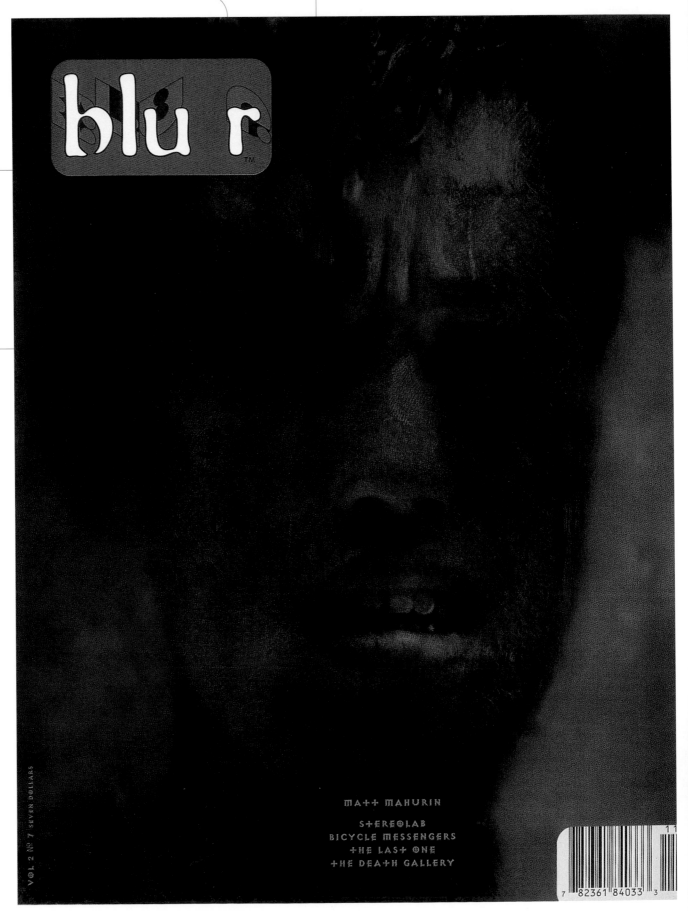

blu r ™

VOL 2 NO 7 SEVEN DOLLARS

MATT MAHURIN

STEREOLAB
BICYCLE MESSENGERS
THE LAST ONE
THE DEATH GALLERY

plazm

18

Plazm Magazine
Designer: Scott Clum
Client: Plazm/magazine
publisher
Concept: "Light and film
techniques showing the
organic essences of apple
blossoms and film, to
create a frozen moment
that captured a presence
without digital
manipulation."

In 1993, Elliott Earls received his master of fine arts from Cranbrook Academy of Art. Upon graduation, his experimentation with nonlinear digital video, spoken word poetry, music composition and design led him to form The Apollo Program.

Earls's posters entitled "The Conversion of Saint Paul," "Throwing Apples at the Sun," "The Temptation of Saint Wolfgang" and "She a Capulet" are part of the permanent collection of the Cooper-Hewitt National Design Museum Smithsonian Institution. His type designs are distributed worldwide by Émigré, Inc. His commercial work includes two recent TV commercials for The Cartoon Network in the United Kingdom as well as an interactive documentary on the work of Frank Gehry for Casabella in Italy. Earls was recently a visiting artist at Benetton's research center, Fabrica. He has also been a visiting artist at Maine College of Art, Cranbrook Academy of Art, Eastern Michigan University and the University of North Carolina at Chapel Hill.

The Apollo Program's commercial clients include Elektra Entertainment, Nonesuch Records, Little Brown & Co., Scribner Publishing Co., Polygram Classics and Jazz, The Voyager Company and Janus Films.

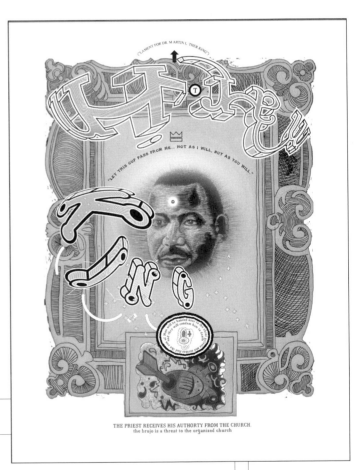

MAX, King
Designer: Elliott Earls
Client: Émigré/magazine and font distributor
Concept: According to Earls, "All the portraits in this series were an examination of historical figures whose ideas have had a personal and deep impact upon my life."

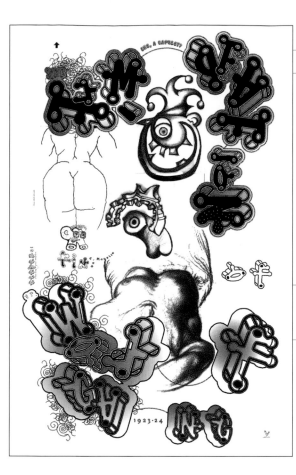

The Temptation of Saint Wolfgang
Designer: Elliott Earls
Client: Self
Concept: "In 1995 I designed a poster entitled 'The Conversion of Saint Paul.' When I printed the poster, I was confused. I thought it was quite possibly the ugliest thing I had ever designed. As time passed, I began to really enjoy this poster and began to really fall back in love with my work. So in 1998, when I designed 'The Temptation of Saint Wolfgang,' I attempted to go through a very similar process. I attempted to design something that would challenge my own definitions of beauty."

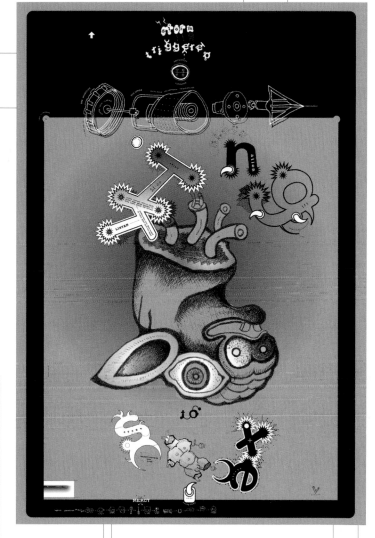

Mad King
Designer: Elliott Earls
Client: Self
Concept: "This piece was very straightforward. It was a performance announcement. It utilizes a sketch from my sketchbooks, a screen printed in two colors on the least expensive paper I could find."

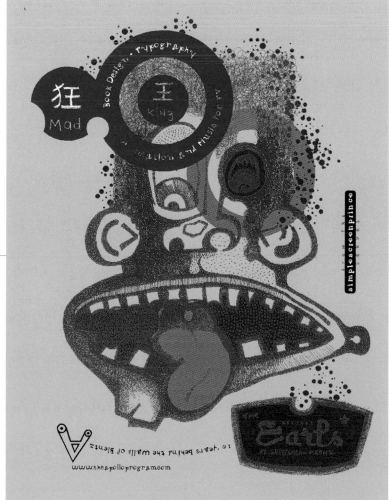

Storm Triggered Cloud King to Sex
Designer: Elliott Earls
Client: Self
Concept: "The title says it all. While designing this piece, I wanted to attempt to embody a form of 'aesthetic sexuality' that seems to be brought on by nature. Sometimes I think the work should have the same strange, powerful voodoo that is contained within sexual attraction. Like when you were twenty, hangin' on a Saturday night, she walked by and... get the picture?"

Carlos Segura, a Cuban native, came to the United States in 1965. After drumming in a local band, he used his portfolio of band promotions to get his first job as a production artist. Segura worked in advertising agencies, including Marsteller, Foote Cone & Belding, Young & Rubicam and Ketchum, in both Chicago and Pittsburgh. Realizing he was not happy creatively, he started Segura Inc. in 1991 to pursue design, while trying to put as much fine art into commercial art as possible. In 1994, Segura and Scott Smith started [T-26], a new digital type foundry, to explore the typographical side of the business, and they later started an independent record label, Thickface Records. Segura considers himself fortunate to have done some very interesting work, met some fine people and had the opportunity to do something for a living that he really enjoys.

Stalker Set Poster
Designer: Carlos Segura
Client: [T-26]/type foundry

Concept: Segura says the inspiration behind this piece was simple: to promote a new font from the [T-26] Digital Type Foundry.

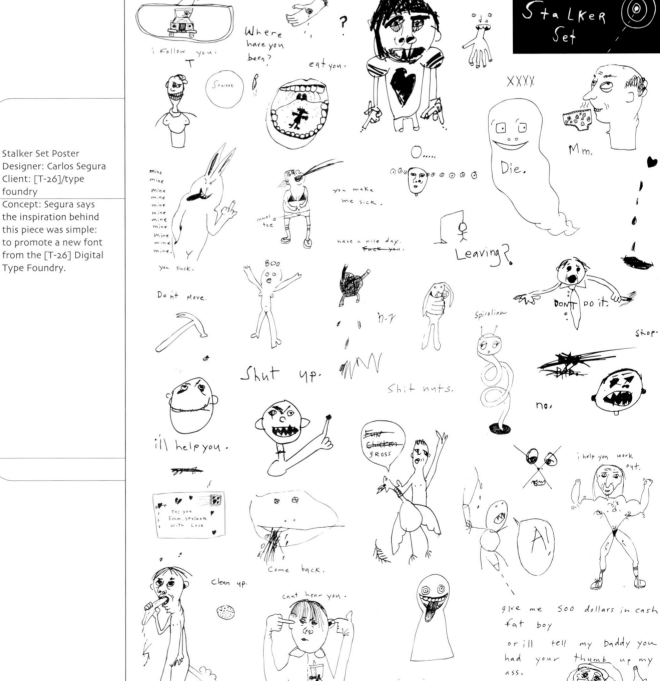

Q101's LIVE101 Poster
Designer: Carlos Segura
Illustrator: Eric Ravenstein
Client: Q101 Radio/Chicago radio station
Concept: The promotion of a radio station event.

TOIT Poster
Designer: Carlos Segura
Font designer: Kivart
Client: [T-26]/type foundry
Concept: Again, promotion of a font was the inspiration behind this piece.

TYPY2K
Designers: Carlos Segura, Thop
Client: Type Director Club,
NY/typography conference
Concept: The event itself was the
inspiration for this piece: The 2000
Type Conference by the Type
Director Club of New York.

Q101's Jamboree 2000
Designers: Carlos Segura, Thop, Laura
Husmann, Anisa Suthayalai
Illustrators: Thop, Laura Husmann,
Anisa Suthayalai, Eric Ravenstein
Client: Q101 Radio/Chicago radio station
Concept: The promotion of Q101 Radio's
summer concert in Chicago.

Target Poster
Designer: Carlos Segura
Font designer: Tomi Haaparanta
Client: [T-26]/type foundry
Concept: Promotion of a font from Segura's own [T-26] digital type foundry.

BLK/MRKT inc. is a visual communications agency that uses the graphic, photographic and video arts to create design and marketing campaigns for the branding of companies. Philip de Wolff, Shepard Fairey and Dave Kinsey started BLK/MRKT in 1997, focusing on designing for action sports companies, but the client base quickly expanded to include the music, movie and clothing industries. Clients include Pepsi-Cola Company, Levi Strauss, Stanlee Media, DreamWorks SKG, Virgin Records, Netscape, Emap USA, Listen.com, Sierra Club and MCA. Dave Kinsey, whose work is featured here, began in graffiti art and continues to use the urban landscape as his canvas. Shepard Fairey, also featured, started his design career at the Rhode Island School of Design with an ambitious mocking street campaign featuring Andre the Giant.

DJ Spooky Riddim Warfare CD Packaging
Designer: Dave Kinsey
Art director: Paul Miller
Client: Outpost Records/Asphodel Records
Concept: Space Invaders video game.

At the Drive-In
Tour Poster
Designer:
Shepard Fairey
Art director:
Shepard Fairey
Client: Grand Royal
Records
Concept: Pop
culture and
propaganda.

For Those Who Stand—A Gay Rights Benefit Compilation
Designer: Shepard Fairey
Art director: Shepard Fairey
Client: Tear It Down Records
Concept: Fairey says this piece is about "youthful angst and desperation channeled to bring about positive social change."

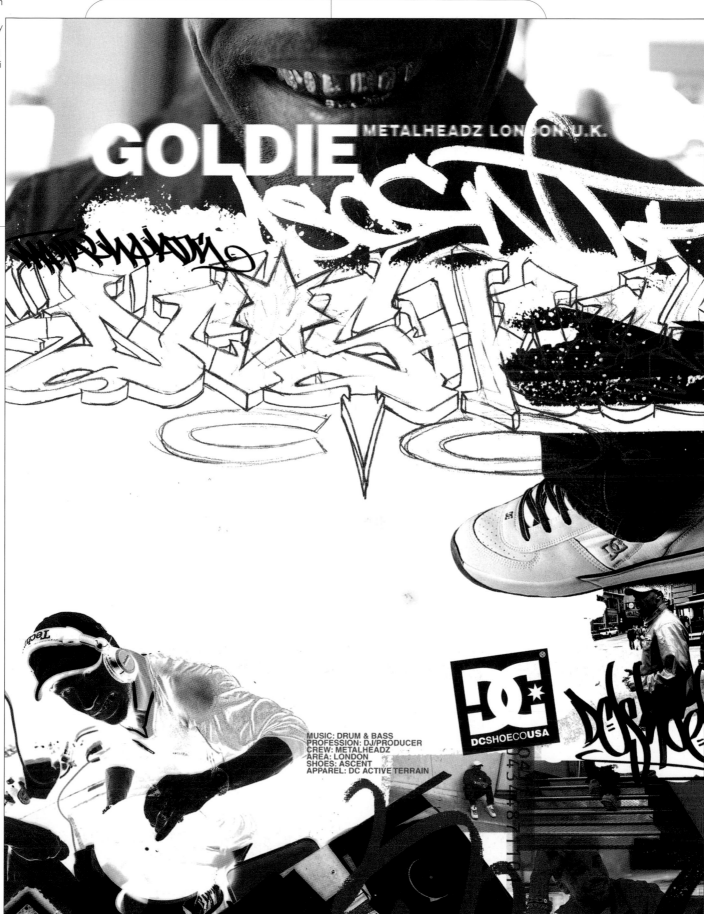

DC Active Terrain Goldie Ad
Designer: Dave Kinsey
Art Directors: Ken Block, Damon Way, Dave Kinsey
Client: DC Shoes
Concept: Lodown Magazine, graffiti art culture, electronic music.

GOLDIE

METALHEADZ LONDON U.K.

MUSIC: DRUM & BASS
PROFESSION: DJ/PRODUCER
CREW: METALHEADZ
AREA: LONDON
SHOES: ASCENT
APPAREL: DC ACTIVE TERRAIN

DC
DCSHOECOUSA

TO SEE THE LATEST NEWS, TEAM INFORMATION AND
SHOES, VISIT OUR WEB SITE AT

Adam C. Levite and Francine Hermelin established Associates in Science in 1997. Associates in Science, located in New York, is a collective of artists, artisans and designers dedicated to high-level retinal immersion, the advancement of knowledge and the public appreciation of wonder.

The artists at Associates in Science say they get their inspiration from a jumble of ideas and objects, including "the animal kingdom (excluding mammals), mumbling, archigram, undefined programs, artificial realities, vans, R. Buckminster Fuller, Wild Pitch, layered ephemera, architecture, 1970s modernism, airports, New York subways, Japanese newspapers, Neitsche and a healthy fear of mortality."

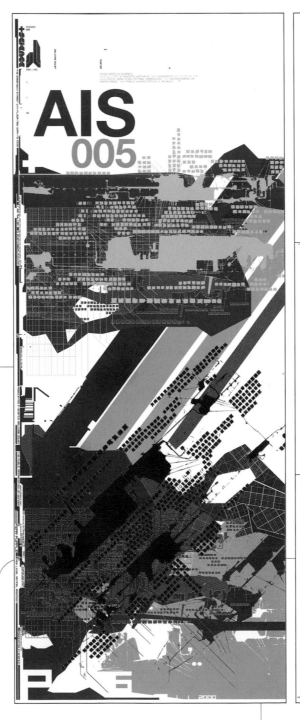

Welcome Doubt
Designer: Edward Taylor
Art director: Adam C. Levite
Client: Self

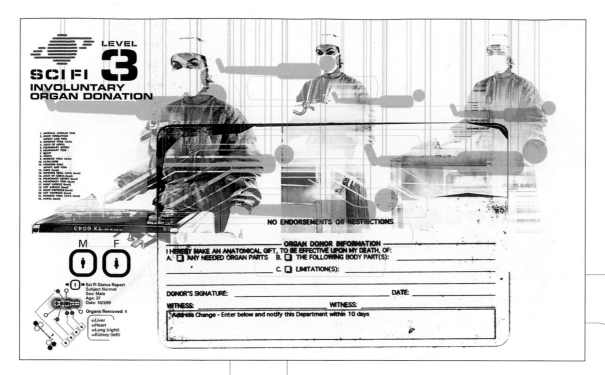

Sci Fi Channel Image Exploration
Designers: Edward Taylor, Mark Owens
Art director: Adam C. Levite
Client: Sci Fi Channel/television station

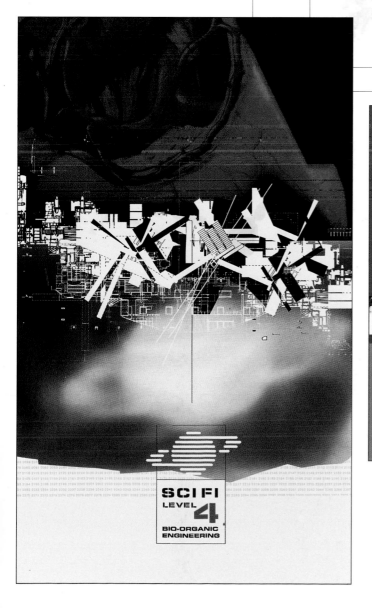

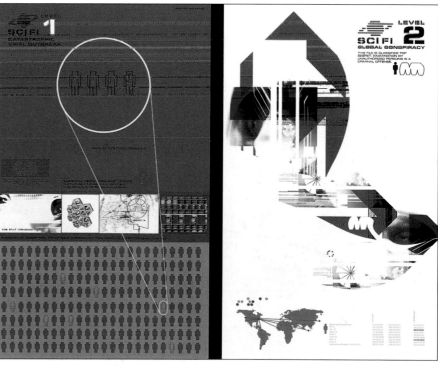

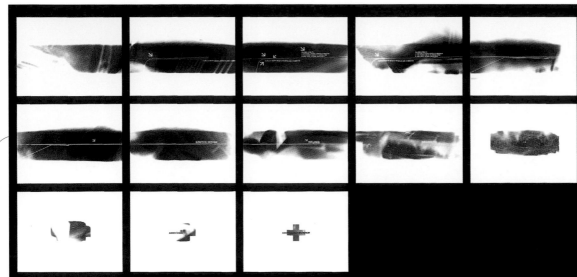

Science :30 Promo
Designer: Edward Taylor
Art director: Adam C. Levite
Client: Self

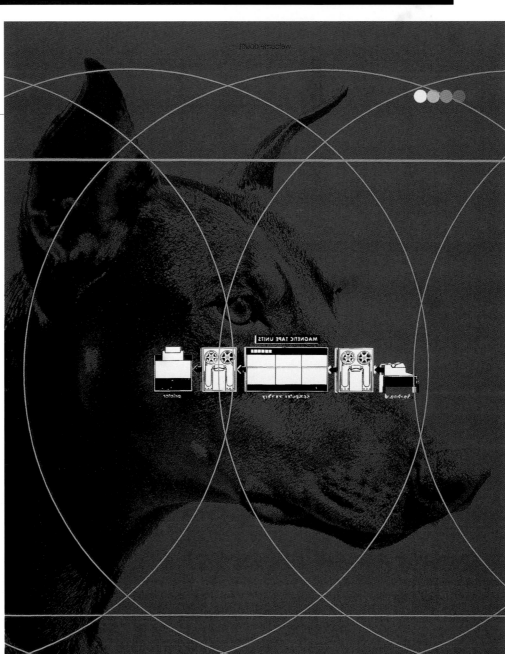

Dog/Magnetic
Tape Units
Art director: Adam C.
Levite
Client: Self

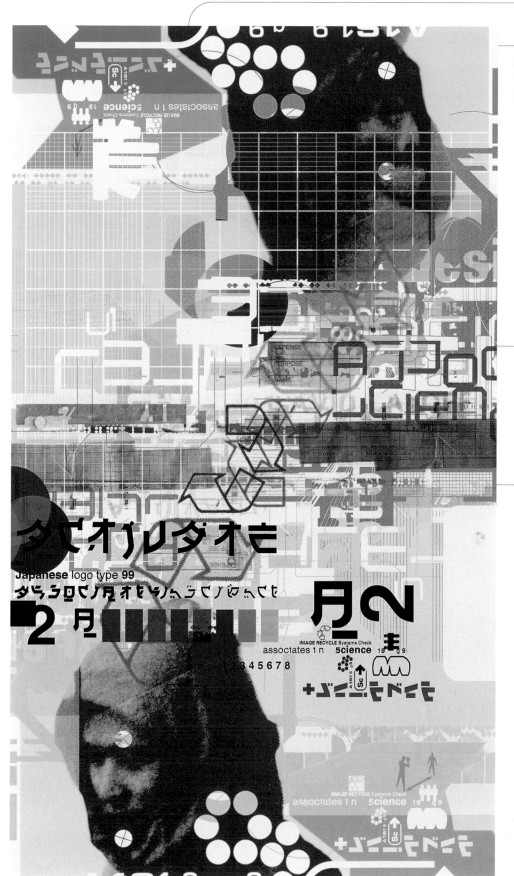

Japanese Type/Chinatown
Designer: Edward Taylor
Art director: Adam C. Levite
Client: Self

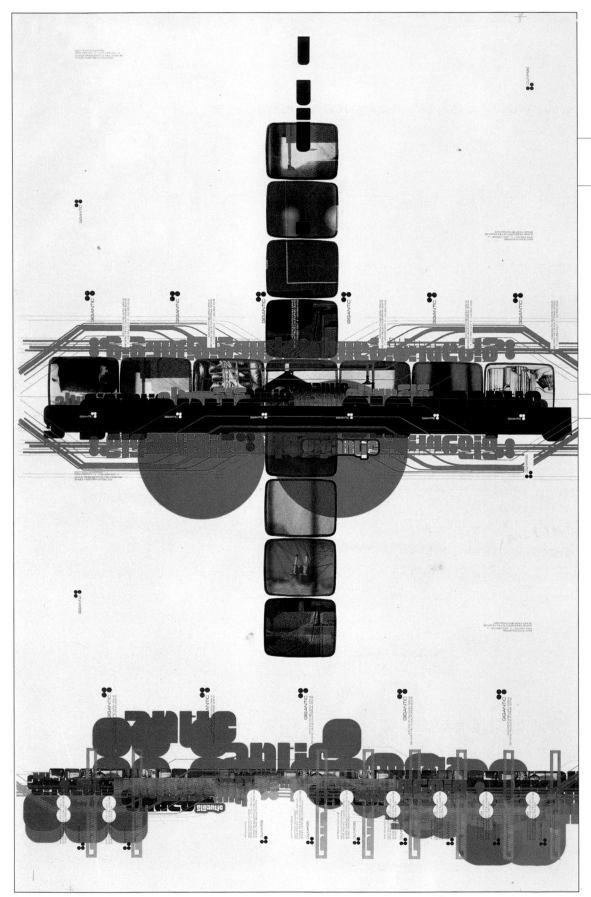

Gigantic
Productions
Poster
Designer: Edward
Taylor
Art director:
Adam C. Levite
Client: Gigantic
Productions/music
video producers

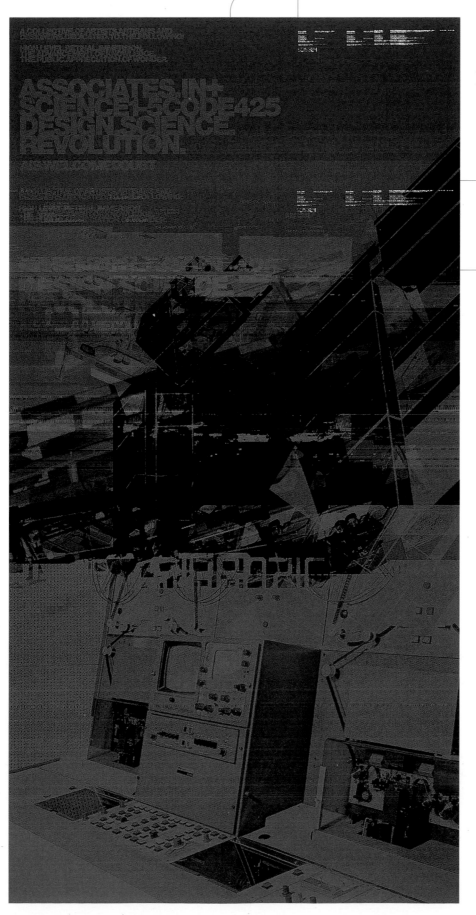

Design. Science.
Revolution.
Designer:
Edward Taylor
Art director:
Adam C. Levite

GRAPHIC HAVOC

Graphic Havoc is a visual agency including Sadek Bazarra, Randall Lane, Derek Lerner and David Merten. They are a multidisciplinary design group specializing in unique solutions for international clients.

The artists at Graphic Havoc work together in a collaborative environment — no "art directors," "production assistants" or "senior management." Each designer at Graphic Havoc has an artist's background full of music, skateboarding, graffiti, painting, drawing, photocopying, industrial design and engineering, though none of them went to school specifically for graphic design or business.

Their visual language is assembled from their lives. Everything from the fine arts and art history, contemporary designers, philosophy and social theory, to the everyday object serves as inspiration behind the work. Graphic Havoc provides the means for a client to explore these realms and create unique solutions to their problems. Clients include Adidas International, Art Papers Magazine, AT&T, Brainwash Marketing Group, The Cartoon Network, Coca-Cola Company, IBM, MCI, Strictly Rhythm Records, Vagrant Records and zapzoom.com.

Sneak Attack
Designer: Graphic Havoc
Client: Slight of Hand Promotions, Atlanta, Georgia

Moving Shadow, Breakbeat Science Tour
Designer: Graphic Havoc
Client: Slight of Hand Promotions, Atlanta, Georgia

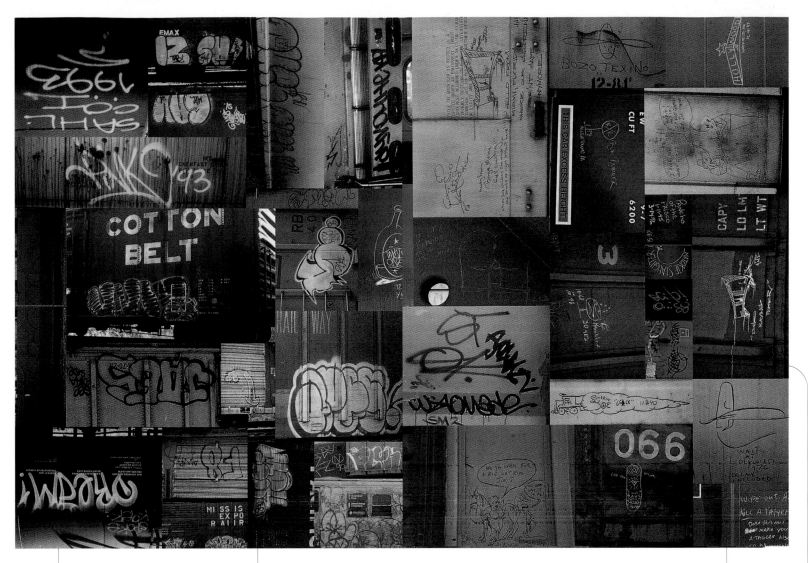

Steel Wheels
Designer: Graphic Havoc
Client: FotoKings
Concept: "Steel Wheels Magazine is a pictorial and literary journal covering graffiti on trains around the globe," say the designers at Graphic Havoc. "Steel Wheels will cover train graffiti from its humble beginnings on the Philadelphia and New York transit authorities to the explosion of aerosol graffiti on the North American freight system, as well as train scenes in Europe and Australia."

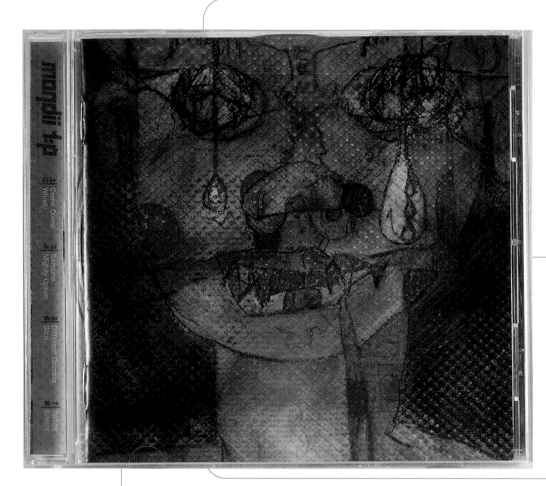

Mondii CD
Designer: Graphic Havoc
Client: HeftyRecords/record label
Concept: "The basis of the design was to incorporate the drawings of the artist's younger sister."

all songs by: Nao Sugimoto
except "Bico": John Hughes / Nao Sugimoto

mix & additional treatments: John Hughes
mixed at: Hefty
mastering: Roger Seibel at SAE
drawings: Ann / Cheason
design: Graphic Havoc avisualagency
thanks: John, Scott, Cheason, Ann, Noriyuki, Ogi

contact: mondii@aqua.plala.or.jp

Young Blood Gallery Poster
Designer: Graphic Havoc
Client: Young Blood Gallery of Atlanta, Georgia/art gallery
Concept: "The Young Blood Gallery May 6 show flyer was designed for a group show using elements of each of the three artists' work. Additional design elements were added in the 'bleed' areas so that the press sheet could be used as a promotional poster."

◄ VERY RARE AND EXPENSIVE LIMITED EDITION POSTER! ►

Kung Fu Knowledge
Designer: Graphic Havoc
Client: Slight of Hand Promotions, Atlanta, Georgia
Concept: "Graphic Havoc was asked by Slight of Hand to design invitations and flyers for each of its drum and bass parties. We took inspiration from the culture of drum and bass and then tried to visually represent the culture for each of the pieces."

PMcD Design is New York-based design firm that specializes in broadcast design. Founded in the spring of 1993 by Patrick McDonough, PMcD provides all phases of design development, graphic production, film direction, music/sound design and corporate image.

PMcD Design brings an unusual creative process to each project by developing focused partnerships with its clients. Every project is given a unique signature that addresses the branding, marketing and packaging needs of corporate identity that is competing in a rapidly changing and converged marketplace. A specialized team of design and production personnel is assembled from a rich and diversified talent base to ensure that the right tools and talent are synergistically joined to the right job.

McDonough is involved in every facet of design and production, insuring a consistent and original approach from concept development to final execution. By establishing the company on an intimate scale, PMcD Design cultivates a personal vision for each company that invites innovation and participation in the development of a shared vision for a project.

Winter X Games
Designer: Steve Tozzi
Art director: Patrick McDonough
Client: ESPN
Concept: "Taking reference from the culture of extreme sports, Winter X Games type design recalls the look and feel of surf and snowboard aesthetics. Clean lines, rounded curves and thick edges pull the logos out from densely layered kinetic backgrounds. The extruded forms become objects that resonate with the energy of a finely tuned ski or snowboard," says McDonough.

DON QUIXOTE

TNT Don Quixote Trailer Title
Designer: Alex Smith
Art director: Patrick McDonough
Client: TNT
Concept: "The classic story of Don Quixote is seen through a modern lens," explains McDonough. "The title treatment hints at a classic manuscript with contemporary overtones, while the swirling madness of a windmill gone awry provides the animation arc of the show logo."

Oxygen Network/Trackers Show Packaging
Designers: Patrick McDonough, Michael Grana
Art director: Patrick McDonough
Live-action director: Suzanne Kiley
Editor: Oliver Wicki of Blue Rock Editing Co., NYC
Digital composite: Jason Conradt of Edgeworx, NYC
Client: Oxygen Network/television station
Concept: "Trackers is a live TV show on the Oxygen
Network where girls gather to collaborate, create
and express themselves with freedom," says
McDonough. "The wild posting walls in New York
served as inspiration and became the environment
for girls to congregate, experiment and leave their
marks on the world. The Trackers logo represents
the changing nature of a teen girl's life. The logo
signifies this mutability through the use of multiple
fonts and reiterations of the word 'Trackers.' "

SEE ING RED

Invitation
Designer: Alex Smith
Art director: Patrick McDonough
Concept: This invitation was inspired by
the party location, The Red Room.

wednesday, JUNE **14,2000**

6-9pm

@

**THE
REDROOM**
2040 SAINT CHARLES AVE
NOLA

R 2

COCKTAILS + HORS D'OEUVRES
LIVE MUSIC

PMCD + ELIAS ASSOCIATES + BLACK LOGIC

Charles Wilkin created Automatic Art and Design in Columbus, Ohio, in 1994 as an outlet for conceptual graphic design, illustration, new media and fine art. The studio is, in essence, a collection of thoughts, images and instinct, or rather a process of assembly that informally connects art and human nature.

As an extension of Automatic's experimental process, Wilkin developed Prototype Experimental Foundry as a means to transpose the organic nature of his work into typographic form.

Automatic's clients include American Eagle, Bio-Box, Capricorn Records, E! Television, Proctor & Gamble, Target, Urban Outfitters, Limited Too and Cahan & Associates.

Capitol Records Ad
Designer: Charles Wilkin
Art directors: Charles Wilkin, Jeff Fey of Capitol Records
Client: Capitol Records/record label
Concept: "Music-makers," Wilkin answers simply. "This was the 1998 ad for Capitol Records for the MTV Video Music Award booklet. The theme for the book and the ad was centered around 'music-makers,' which could be anything from a piano player to wind blowing through a cornfield."

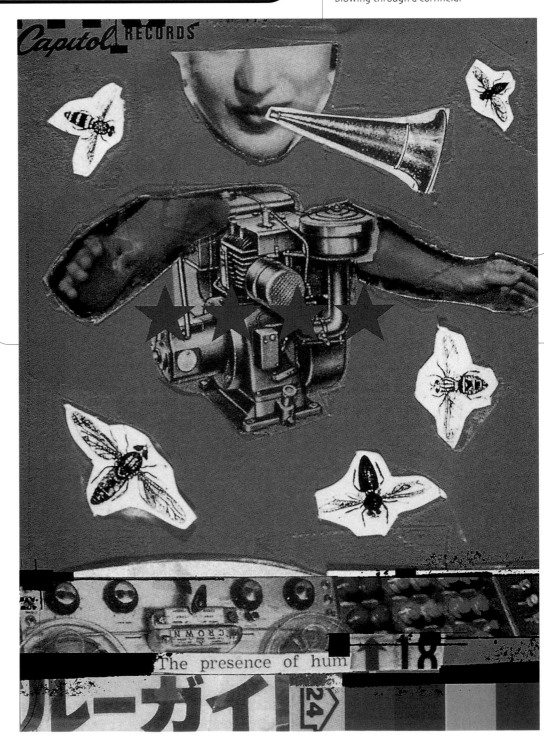

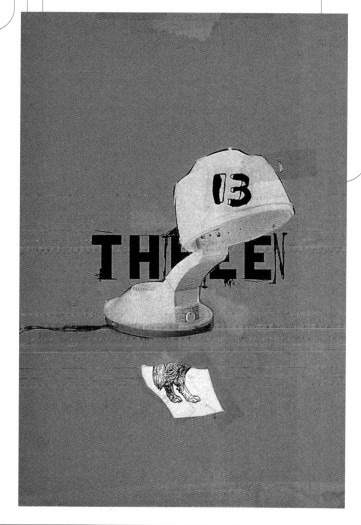

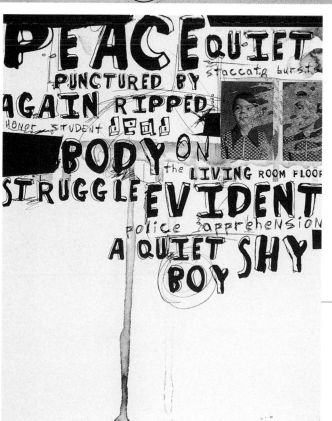

Alexei Tylevich is a Los Angeles-based designer/director working with a variety of clients. His experience spans network television and commercials, high-end computer animation and motion graphics, live-action directing and design for print and Web. Prior to setting up his own studio, from 1996 to 1998 he was the art director at Channel One News where he was responsible for all on-air graphics and overall show packaging.

Tylevich's motion graphic and typographic work have garnered widespread professional recognition. His design work has been featured in numerous publications or exhibitions, including I.D. Magazine, Creative Review, Eye, Wired magazine, the American Center for Design, Broadcast Designers Association, and SIGGRAPH. Tylevich's interview and work were featured in a program "Graphic Design: The State of Art" that aired on a Dutch television station. Tylevich has also conducted numerous workshops and lectures internationally.

UNKNOWN THURSDAZE
Designer: Alexei Tylevich
Client: UNKNOWN/nightclub
Concept: "The logo and a series of flyers were created to promote the weekly DJ sessions," says Tylevich. "Since the location of it changes from week to week, there is no address specified anywhere on the flyers. The music ranges from trance to drum and bass, and the promoter's goal is to attract as wide a following as possible."

SCI-Arc "Butterfly" Poster
Designer: Alexei Tylevich
Client: SCI-Arc/Educational institution
Concept: "This poster was an attempt to reconcile and find a common denominator that adequately represents a group of leading architecture practitioners and theorists. The invited lecturers are selected on the basis of a certain set of criteria determined by students and faculty. An umbrella concept—in this case, 'Butterfly'—is normally chosen as a way of tying together the varying practices on display. 'Butterfly' was meant to point to chaos theory, Lorentz's strange attractors (known as the butterfly effect), as well as to evoke purely associative and sensual connotations. The time line on the poster is twisted into a loop, making the hierarchy and chronological connections less prominent, emphasizing instead a sense of synchronicity and interconnectivity. The 'voluptuous' floating red blob alludes to the return of 'the inflatable moment' in architectural discourse. On a textual level, the palimpsest of cathode signals (SCI-Arc logo) is juxtaposed with the 'ready-made' Day-Glo plastic pigment of the blob and 'Butterfly' type. The ideas of overlap and inherent two-dimensionality of human perception are negotiated through a series of formal gestures. (The shape of the blob was arrived at by overlapping all the letters of the word 'butterfly.')"

Creative Review 20th Anniversary
Designer: Alexei Tylevich
Client: Creative Review/Magazine
Concept: "This image celebrates the twentieth anniversary of the British design and advertising magazine Creative Review. Twenty internationally recognized designers were asked to come up with their own visual interpretation of the subject matter. This image was based on an experimental three-dimensional typeface in progress."

Blood of Abraham
Designer: Alexei Tylevich
Client: Blood of Abraham/hip-hop group with the Mastergip label
Concept: Conspiracy theories and local news.

129

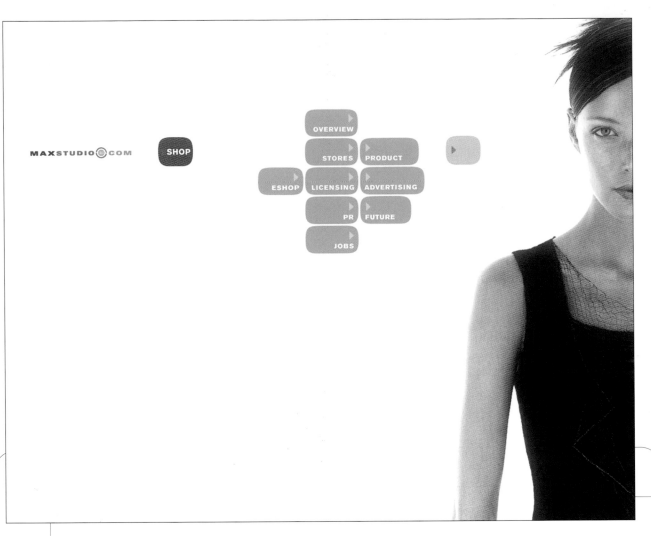

Maxstudio.com E-Shop
Art director: Alexei Tylevich
Product designers: George Yu, Jason King, Samson Chua, Robert Fabijaniak of Design Office;
Peabody Engineering; Performance Composites
Client: Leon Max (Max Studio, Pasadena, California)/clothing company
Concept: "The Max Studio e-commerce kiosk is a freestanding computer station that is linked to the company's on-line shopping Web site. Shoppers find these kiosks in a variety of locations, including shopping centers, airports and hair salons. As a technological object designed for the fashion industry, it is important that the kiosk project an image that is attractive and evocative to sophisticated, brand-conscious consumers. The design was inspired by the idea of luminescence. We used materials that would translate this theme into an appropriately mysterious evocation of the virtual world of the Web."

Clock in Shinyokohama
Designers: Alexei Tylevich; George Yu, Jason King, Toshifumi Nagura,
Kunihiro Yamada from Design Office, an architectural firm
Client: Mazya Housing Co., Japan/housing developer
Concept: According to Tylevich, this fully functional clock on the side of a
condominium in Japan is "located in a densely populated area, facing one of
the major train stations in the Tokyo vicinity, Shinyokohama. The goal was
to come up with a flexible design that would enable the passerby to read
time both at night and during the day. The system of interlocking rows of
LED lights was developed to accommodate the unusual trajectory of the
hour hand. Mounted on the very top of the wall, the hour hand moves only
180 degrees and back. (The custom mechanism was built by Citizen.) The
shape of the numbers was inspired by retro video games and justified by the
perforation pattern of standard sheet metal."

Databass
Designer: Alexei Tylevich
Client: Databass/live music Web show
Concept: "Databass is a live video-streaming Web show based in Los
Angeles. World-class DJs are invited to spin weekly, and their sets are
broadcast live on the Internet. The guest DJ lineup is predominantly
drum and bass, with some techno and trance guest DJs every once in a
while. The logo design was inspired by Space Invaders and Tech Itch &
Decoder."

After studying graphic design at the York College of Arts & Technology, Chris Ashworth and two college friends set up their own design partnership called Orange. Then in 1993, he became a designer at Eg.G design studio in Sheffield, England. Two years later, he established his own design studio, Substance, with two other partners, and began doing work for MTV Europe, Booth-Clibbon Editions, Creative Review, WEA Records and Sheffield University. The recognition he received there led to his becoming an art director and designer for Ray Gun magazine, an international music and style publication based in Los Angeles. In 1998, Ashworth was onto his third design studio partnership when he created Still in central London. Currently, Ashworth is the design director of Gettyone Design Studio.

Ray Gun
Designers: Chris Ashworth, Amand A. Sissons
Client: Ray Gun Publishing/Music magazine
Concept: "The inspiration was the fusion of styles between Nirvana and Led Zep. One side is clean, the other side is dirty."

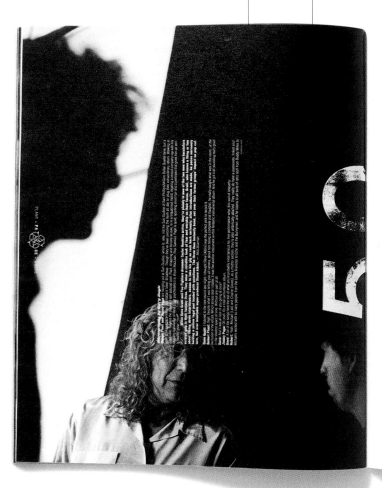

Libido Club Flyer
Designers: Chris Ashworth, Gary Brown, Simon Dixon
Client: Sheffield Night Club
Concept: "The client wanted a flyer that would stand out," says Ashworth. "We decided to go for a more sophisticated approach, picking muted colors and printing on brown card. All the other flyers at this time were bright colors on shiny paper. We came up with the name, too!"

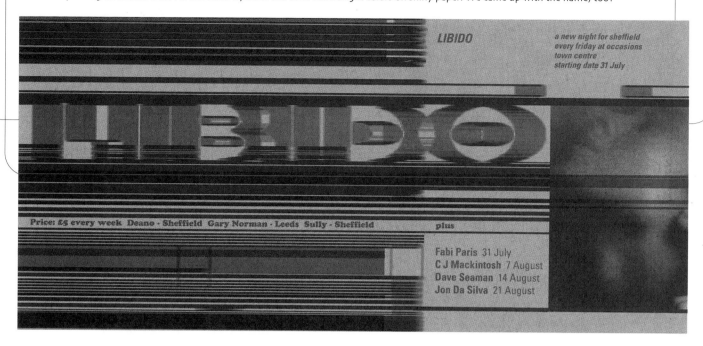

Ray Gun 50 Cover
Designer: Chris Ashworth
Illustrator: Larry Carroll
Photographers: Ian Davies, Peter Davies
Client: Ray Gun Publishing/music magazine
Concept: "As this was the fiftieth anniversary issue, we already had the photographs from a previous issue. I photocopied them and gave them to the illustrator as I knew it would suit his approach."

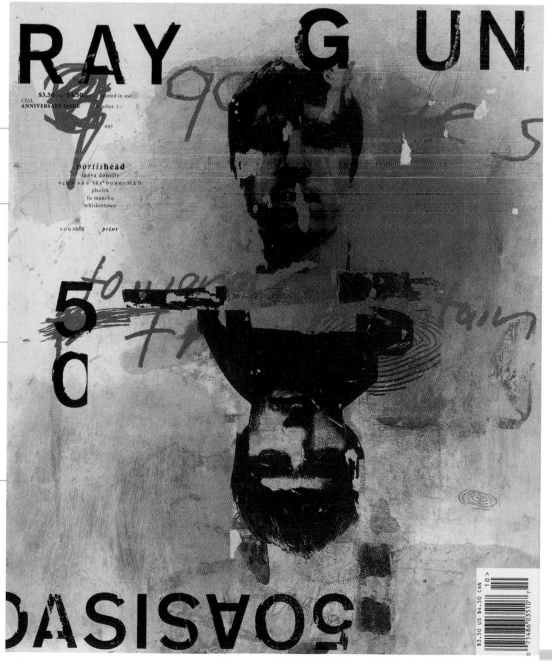

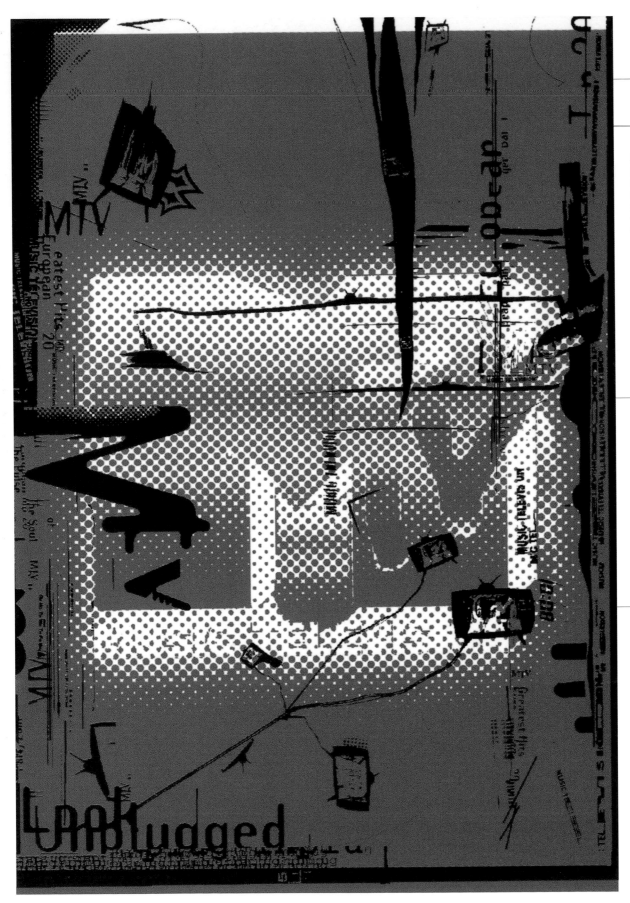

MTV A2 Poster
Designer: Chris Ashworth
Client: MTV Europe
Concept: "This poster was
created as a backdrop to a
TV event. It was used as
'wallpaper.'"

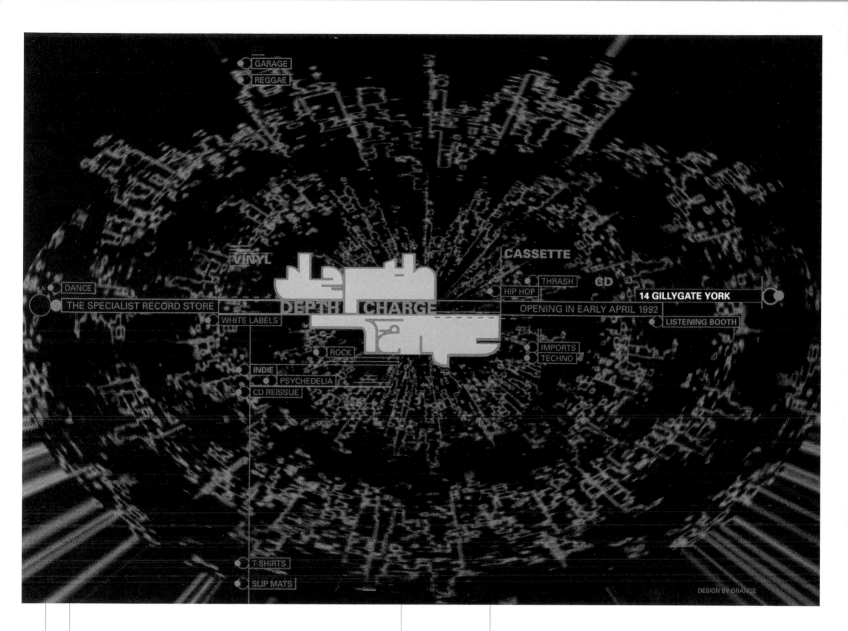

Depth Charge Records as Flyer
Designers: Chris Ashworth, Gary Brown, Simon Dixon
Client: Depth Charge Records/record store
Concept: "The logo was created to mimic a nautical flavor, and all
the music styles were subtly shown as 'depth charges.' This device
became an extra logo for the record shop."

Alexandros Maslatzides of Studio Pangaia was born in Athens, Greece, in 1968. He studied graphic design, photography and digital art in New York at the School of Visual Arts. He soon started experimenting with imagery both in a conventional, handmade way and by using digital technology. His strong urge for personal expression finally led him to create his present form of imagery, which is photo-based mixed media. These images are a combination of his photographic work, digitally processed and then transferred and painted over with acrylics and metal oxides.

Maslatzides is currently also experimenting with music and sound as well as video. He is a senior art director for the DMIND Web-Development Corporation.

Lust
Designer: Alexandros
Maslatzides
Client: Self
Concept: Maslatzides calls this piece that was created for a fine art exhibit "an attempt to focus on the exploitation of the female physical form. At this point there is no face, there's no personality, there's just one focus. Any name would do!"

Prayer
Designer: Alexandros Maslatzides
Client: Portrait commission
Concept: "This portrait attempts to depict the model/client as a priestess in an ancient Egyptian tradition. The piece was supposed to have the feel of a discovered document or tomb."

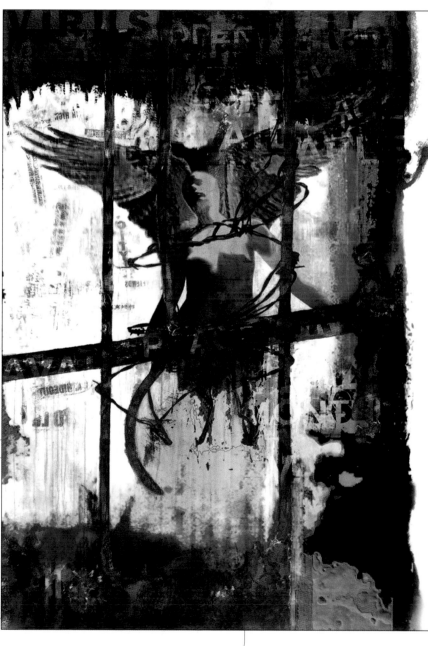

Freedom Angel
Designer: Alexandros Maslatzides
Client: Self
Concept: "Following the theme of 'inner' portraits, this piece is an attempt to depict the coexisting of opposites within the duality of human nature. It's all about the final dominance."

I Am I
Designer: Alexandros Maslatzides
Client: Self
Concept: This self-portrait was "a chronicle search through the ages to find the essence of self. From Adam to life, to birth and death, we find these elements that unify the human species."

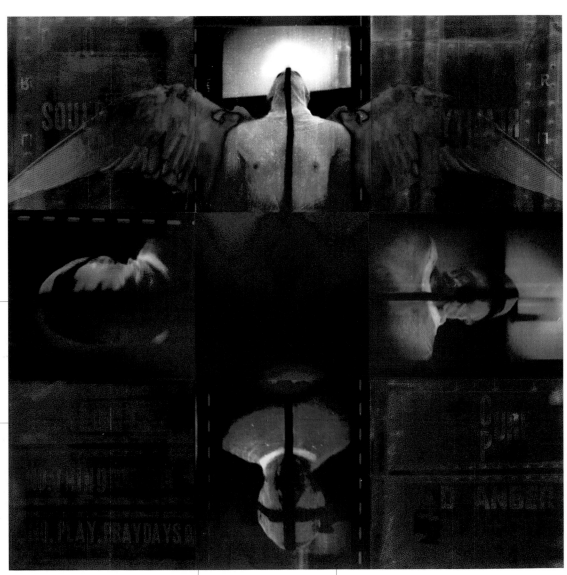

Old Soul
Designer: Alexandros Maslatzides
Client: Portrait commission
Concept: "This piece reflects different steps of inner struggle until the final self-freeing stage. Facing one's demons reveals the true essence of self. Fear is annihilated."

Aphrodite
Designer: Alexandros Maslatzides
Client: Portrait commission
Concept: "The portrait attempts to bridge the gap between the ancient and modern archetype. The client's Greek heritage lended itself to a chronicle searching for these aspects of the human psyche that remain unaltered and eternal."

Decay
Designer: Alexandros Maslatzides
Client: Self
Concept: This piece is about "the struggles of the human pysche as we attempt to understand the combination of decline and emergence taking place in our modern world."

Viktor Koen, a native of Thessaloniki, Greece, holds a bachelor of fine arts degree from the Bezalel Academy of Arts and Design in Jerusalem and a master of fine arts (with honors) from the School of Visual Arts in New York. He is regularly published in The New York Times Book Review, The Nation, Bloomberg Personal, Smart Money, Money and Popular Science magazine. His client list includes Atlantic Records, Delta Airlines, Premiere, Spin, Random House, Putnam Publishing, The Boston Globe and the Chicago Tribune. Koen serves on the faculty of the illustration, digital and foundation departments at Parsons School of Design in New York. He is the founder of Attic Child Press and the creative director of the award-winning design firm LPNYTHink. His paintings, prints and books are shown in galleries and museums in the United States and Europe.

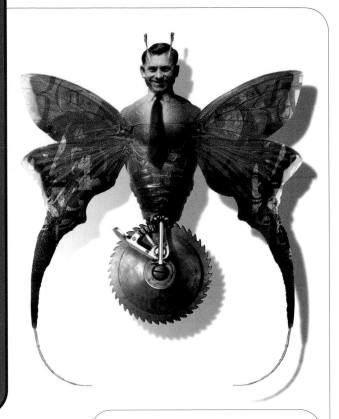

Metalmark
Designer: Viktor Koen
Client: Attic Child Press, NYC
Concept: "Metalmark is one of Plug's foes from the book The Quest for Mug. Like all of Plug's enemies, Metalmark is based on studies for a larger fine art series of prints called 'Zoophoria, Cases of Corporate Reincarnation,' which consists of twenty-four portraits of high executive titleholders that return to life as insects. It's a theme that combines theories and research on social insects, traditional and contemporary corporate structures and job descriptions, and reincarnation scriptures (more specifically the controversial teachings of Pythagoras on transmigration of souls)."

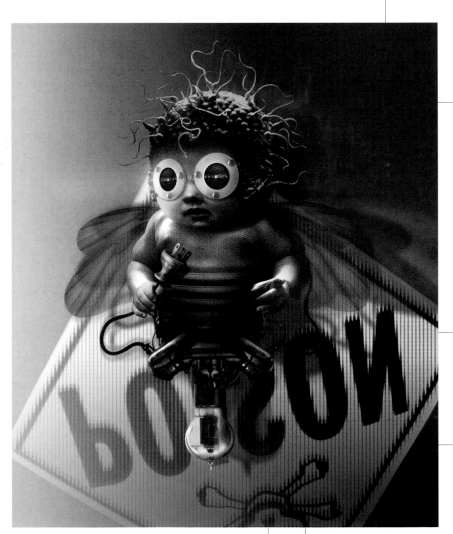

Plug, page from the book The Quest for Mug
Designer: Viktor Koen
Client: Attic Child Press, NYC
Concept: "Plug was created as the antithesis of the 'millennium bug' phenomenon," says Koen. "He is an inspirational device to balance the Y2K catastrophe scenarios. The insect, technology and corporate themes were naturally imbedded and became the main components in the development process of the character. He is pieced together by leftover materials from projects I have been working on during the last year. In a peculiar way composing him out of 'visual debris' suits his complex persona, appearance and the environments he roams. The story was written by Melanie Wallace shortly after she fell in love with Plug."

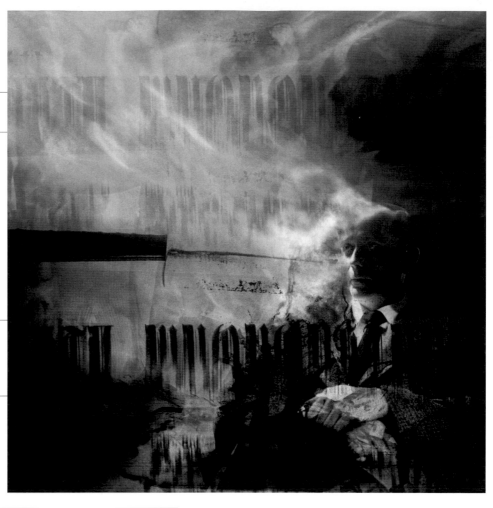

The Poet
Designer: Viktor Koen
Client: Macedonian Museum of
Contemporary Art in Thessaloniki, Greece
Concept: "The Poet is one of seven
contributions of original work to the core
group exhibition "A Vindication of Tlon"
based on a short story by Jorge Luis Borges
at Macedonian Museum of Contemporary
Art in Thessaloniki, Greece. Just as the
mysterious authors of the first Encyclopedia
of Tlon strove to create the world of Tlon in
words, artists are invited to create images
which might reflect such a world."

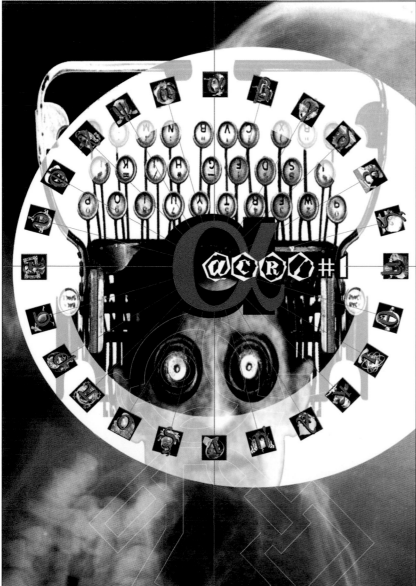

ACRO Magazine Cover, Issue #1
Designer: Viktor Koen
Art director: Agelos Bakas
Client: ACRO magazine/quarterly
magazine on graphic design,
typography and communication
published in Thessaloniki, Greece
Concept: "Imagery from the book
Lexicon, Words and Images of Strange
that was profiled in that issue. Also the
Greek alphabet."

ATTIC CHILD
A child raised in isolation, often locked away in an attic by parents or guardians.

EGOMANIA
Pathological preoccupation with one's ego or, better, with one's self.

LITTLE HANS
The pseudonym of one of Freud's most famous cases, the psychoanalysis of a young boy with a phobia of horses.

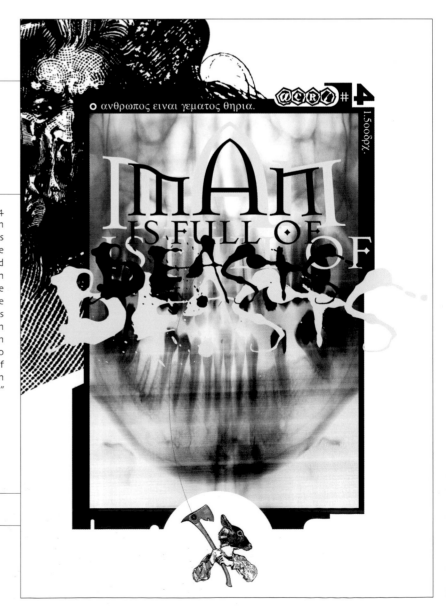

ONEIROPHRENIA
A dreamlike state with some characteristics of simple schizophrenia but without the dissociation typical of that disorder.

UNIPOLAR DEPRESSION
The term is used for cases in which depressive episodes recur without the appearance of the manic phase that is observed in the classic form of bipolar disorder.

WERNICKE'S ENCEPHALOPATHY
Acute brain disorder with eye-movement disfunctions, ataxia, and general mental confusion. It is related to severe alcoholism.

FunnyFarm, The Alphabet of Mental Disorders
Designer: Viktor Koen
Client: Attic Child Press, NYC
Concept: "FunnyFarm is a collection of psychological cases, a mental disorder profile for each letter of the alphabet. A mixture of familiar and virtually unknown conditions whose designations I have found visually charged. The illustrated typeface gives no consideration to the shape or dynamic qualities of the characters when their corresponding icons were created, thus independence is guaranteed from any prerequisite form. Although each piece was composed and illustrated digitally, the final image lacks any fractal effects that would disturb the tradition of its origins."

ACRO Magazine Cover, Issue #4
Designer: Viktor Koen
Art director: Agelos Bakas
Client: ACRO magazine/quarterly magazine on graphic design, typography and communication published in Thessaloniki, Greece
Concept: "The cover title assigned by the magazine editor Agelos Bakas was 'Man is full of beasts, you'll feed one and you'll soon have to feed the lot.' The imagery is taken from the limited edition letterpress portfolio edition of 'FunnyFarm, The Alphabet of Mental Disorders' that was profiled in that issue."

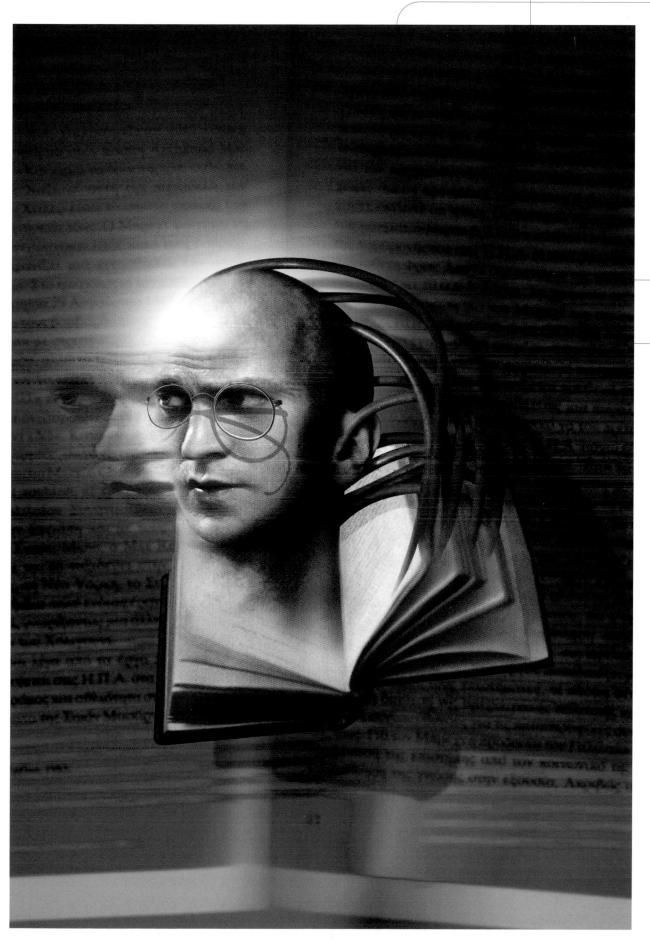

The Content Provider
Designer: Viktor Koen
Client: Paratiritis, publishers and booksellers/art and literature publication in Thessaloniki, Greece
Concept: This full-page illustration is based on a spot illustration originally published in Bloomberg Personal.

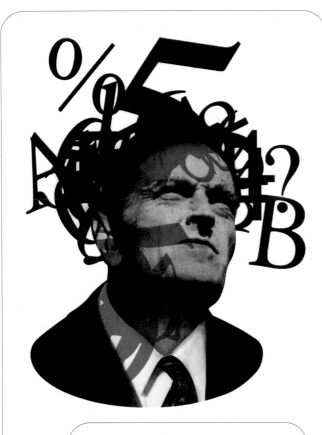

Designer: Viktor Koen
Art director: Cynthia Harris
Client: New Choices/newsstand magazine
Concept: Illustration for an article on the difficulties of choosing a retirement plan.

Typing Proficiency,
Writing Numbers
Designer: Viktor Koen
Client: Self
Concept: These pieces were
created as a part of the show
Tasks & Games, Portraits of the
Never Young. "The obsession with
the 'perfect baby' and children
who would be progressively more
intelligent and fit than the last
generation is an ancient one.
Today through genetic
technologies, social engineering
and developmental psychology,
we believe we can control
previously inaccessible natural
workings that strongly influence
the way children are born, learn
and grow. Tasks & Games depicts
twenty-four children caught in
the pursuit of perfection before
and after their births as a
testimony to a loss of innocence."
The piece "Typing Proficiency" (at
left) won the Viridian Gallery
Eleventh National Juried
Exhibition 2000.

After meeting in college, studying in Rome, Italy, forming several bands (the Slim Guys & the Leisuremen) and eventually moving to New York City to seek their fame and fortune, Stan Stanski and Phil Yarnall quickly grew tired of sitting under the thumb of "The Man." Thus, Smay Vision was born.

As a fledgling graphic design firm in the big city, Stanski and Yarnall took on all work that came their way, from editorial/magazine work to CD packaging. Working connections from their previous employers—Guitar for the Practicing Musician Magazine (Stanski) and PolyGram Records (Yarnall)—they soon branched out their network to most of the major record companies (Warner Brothers Records/Reprise, Universal, MCA, EMI, Elektra, PolyGram, Sony Music) and created packaging for artists ranging from Jimi Hendrix, Janis Joplin and The Velvet Underground to Connie Francis, The Meat Puppets, Earth Wind & Fire and countless others. In addition to music packaging, Smay Vision has created unique designs for The New York Underground Film Festival, The Rock & Roll Hall of Fame, The Source Sports magazine and Billboard Magazine/Custom Publishing.

The work of Smay Vision has been recognized by Communication Arts, PRINT, HOW and The Society of Publication Designers and has been featured in U&lc and IdN (International Designers Network). Their work has been exhibited at The Cooper-Hewitt National Design Museum, The New York Art Directors Club (Young Guns NYC show), AIGA New York Gallery (Sound Off 100 CD Show), The One Club, NY (CD Special Packaging Show) and the permanent collection of the Andy Warhol Museum.

Black People Hate Me Film Title
Designers: Stan Stanski, Phil Yarnall
Client: Andrew Gurland Films/
film company
Concept: Stanski says this piece is "a title treatment for a very funny short film by Andrew Gurland. It's his silo."

Played in Full Editorial Layout
Designers: Stan Stanski, Phil Yarnall
Client: The Source Sports magazine
Concept: The article's content inspired this piece.

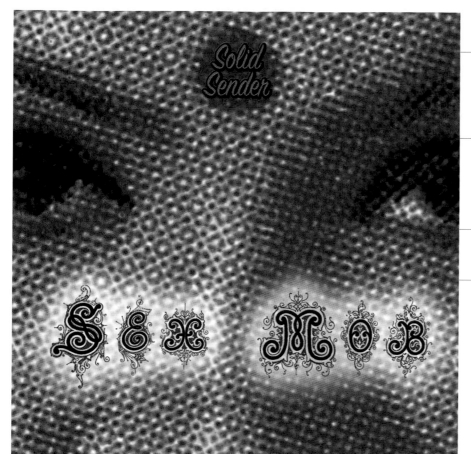

Solid Sender

SEX MOB

Sex Mob
Designers: Stan Stanski,
Phil Yarnall
Client: Knit Records/
Record company
Concept: Stanski calls
this music cover "a little
bit sexy."

Jimi Hendrix Morning
Symphony Ideas CD
Designers: Stan Stanski,
Phil Yarnall
Client: Experience Hendrix,
Dagger Records/
record company
Concept: "This collection
contains music and ideas
that Jimi was working on,"
says Stanski. "Nothing is
finished and for the most
part are sketches he made
on his personal tape
recorder. We wanted
to show the roughness
and sketchy quality
in the cover."

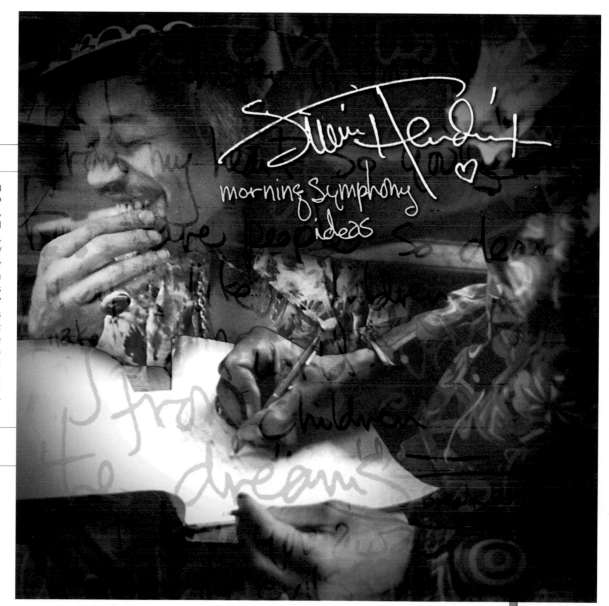

As founder of Faith, Paul Sych received his academic training in design from the Ontario College of Art. He also studied music at York University in Toronto. A jazz musician at heart, he incorporates both his musical and visual passions into his creative processes and solutions.

Under Sych's leadership, Faith's primary goal is to strengthen the relationships between the musical and visual arts. Both share a dependence on tools—the instruments—of expression, and both share the aspect of change over time and movement through space. Faith uses type and other graphic elements as visual notations in their compositions, much like a musician uses aural notations in performance. Of primary importance to Faith's process is maintaining the ability and freedom to express without hesitancy. Sych has focused his design and type sensibilities toward this goal.

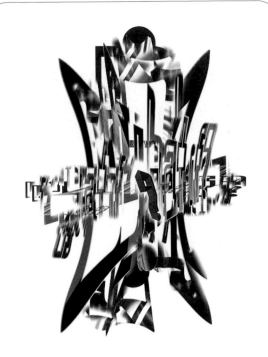

What If?
Designer/Art Director: Paul Sych
Client: Rob Carter, instructor of typography and graphic design at Virginia Commonwealth University
Concept: "Using the term 'What if?' as a metaphor for itself—the question of questions."

Our Father
Designer/Art Director: Paul Sych
Client: Self
Concept: "This piece was intended as a pun on the Lord's Prayer. I altered a few words of this prayer so that it read, 'Our Father, who's art is in heaven' from its original version, which is, 'Our Father, who art in heaven.' (I was always curious who's art is in heaven—Degas, Picasso, Miro?)"

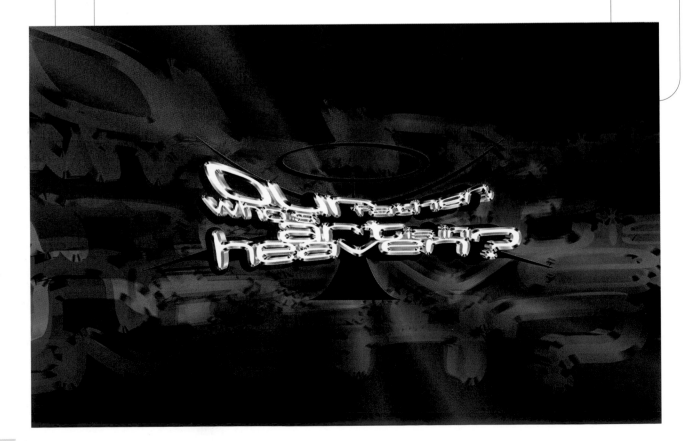

Be Thy Name
Designer: Paul Sych
Client: Rob Carter, instructor of typography and graphic design at Virginia Commonwealth University
Concept: "To believe in oneself."

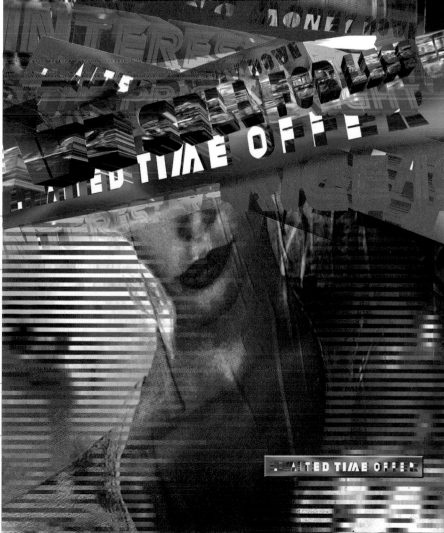

The Price Is Right
Designer: Paul Sych
Client: Self
Concept: "The power of money and what it can and cannot buy."

Fatman
Designer/Art Director: Paul Sych
Client: Self
Concept: "While walking near my studio, I saw the piece of garbage, a flyer for a grocery store, on the pavement. The way it had been folded and crushed resembled two eyes and a sort of Batman-esque mask. I then reworked it a little more so that it had a cape, thus the name 'Fatman.'"

Love Me
Designer/Art Director: PaulSych
Art director: Paul Sych
Client: self
Concept: "A self-indulgent remark."

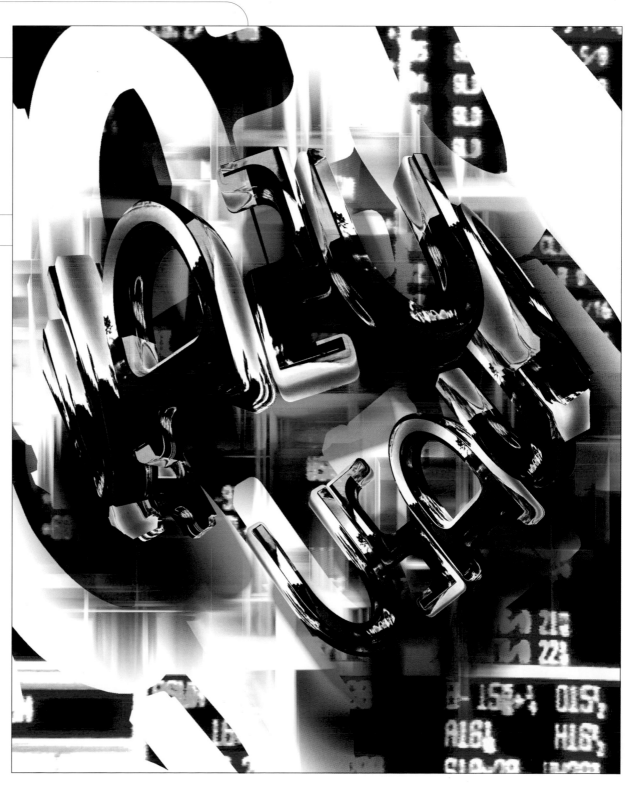

USA
Designer: Paul
Sych
Client: Self
Concept:
According to
Sych, this piece
is about "the
economic
backbone of the
United States."

Slow Hearth Studio is a design firm with an extensive portfolio of work in graphic design, photography, photo-illustration and typography. Sean Mosher-Smith and his wife, Katie, established Slow Hearth in 1992 in Brooklyn after Sean had been senior art director for RCA Records.

Slow Hearth Studio has created everything from Web sites and CD packaging to book covers and editorial photography for clients such as Time magazine, The Village Voice, Viacom, Avon Books, MTV and Universal Records, among others. Slow Hearth's design and photography have been displayed in Communication Arts, The Art Directors Club of New York's "Young Guns" exhibit, IDEA magazine, and IdN Magazine. They often blend their design, typography and photography to produce rich, textual images that range from provocative portraits to dreamlike scenes and eerie landscapes.

Indie Planet Video Stills
Designers: Sean and Katie Mosher-Smith
Client: RCA Records/record company
Concept: "This piece was to promote an Irish pop band and to express their pop sensibilities," says Sean.

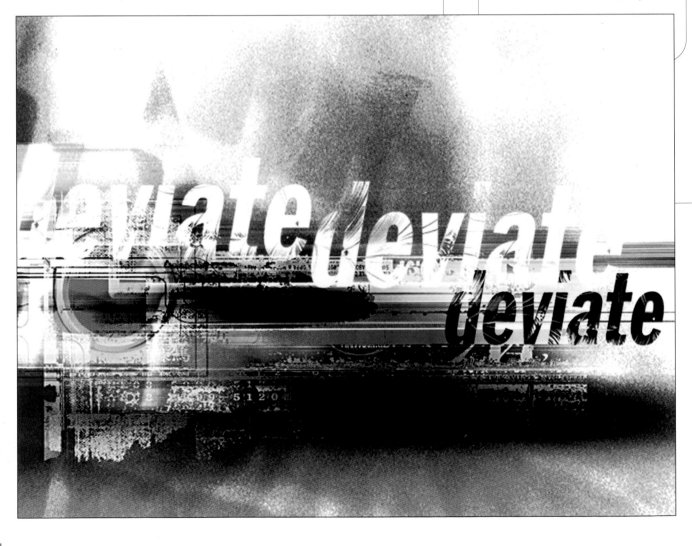

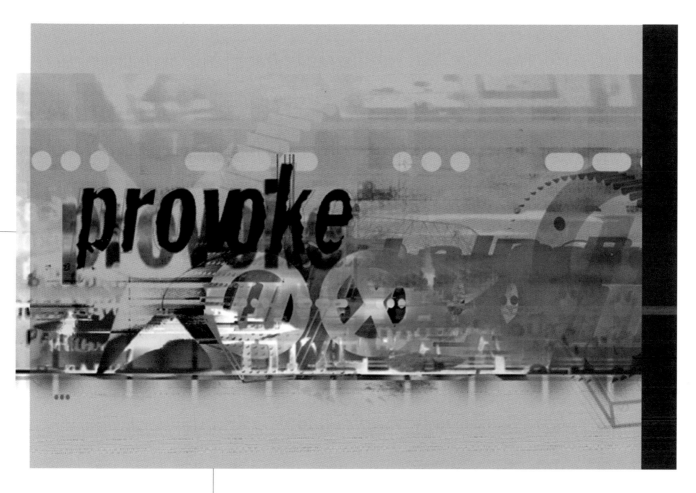

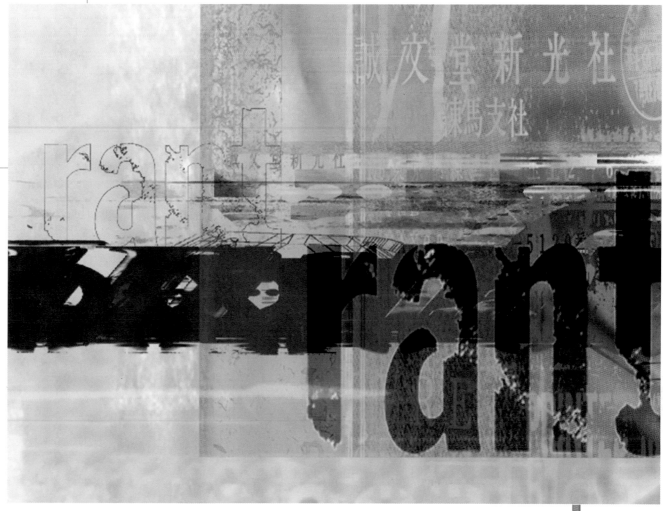

Various Promotional Materials
Designers: Sean and Katie Mosher-Smith
Client: Self
Concept: Self-promotion.

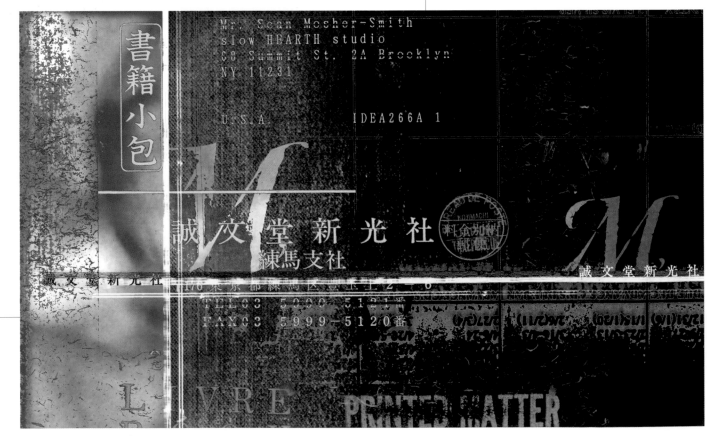

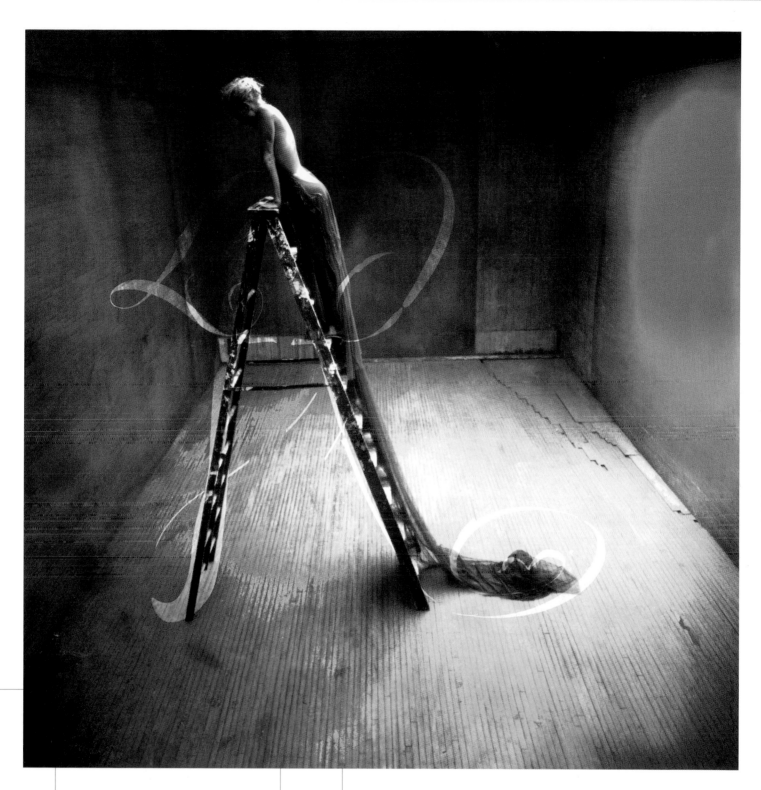

Leah Andreone Package Art
Designer: Sean Mosher-Smith
Client: RCA Records/record company
Concept: "Leah's elegant style."

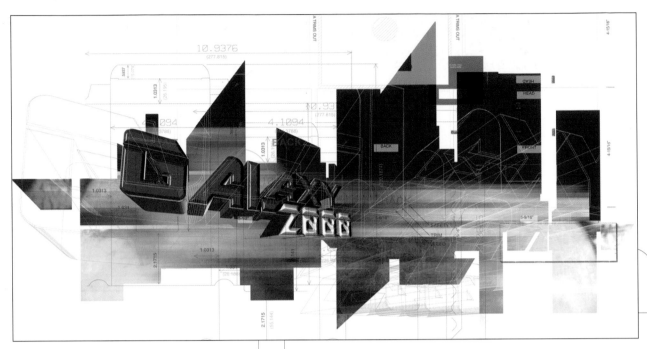

WAR • Galaxy 2000 12"
Designer: Sean Mosher-Smith
Client: Avenue Records/record company
Concept: "Space theme for a remix of a 1970s band."

Ke • Shiny
Designer: Sean Mosher-Smith
Photographer: Kate Swan
Client: RCA Records/record company
Concept: The artist's unique style.

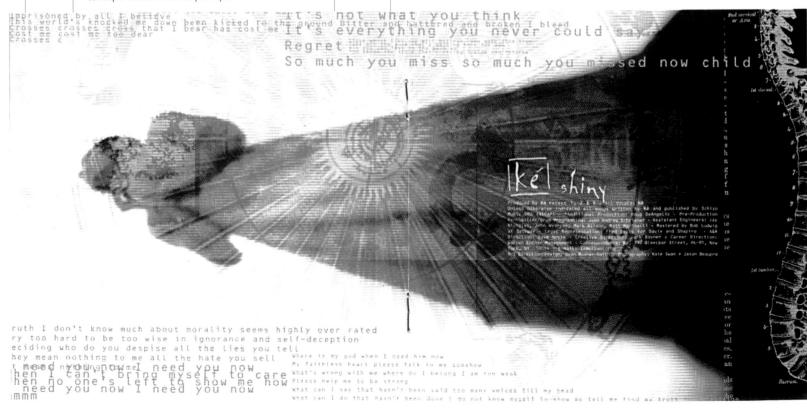

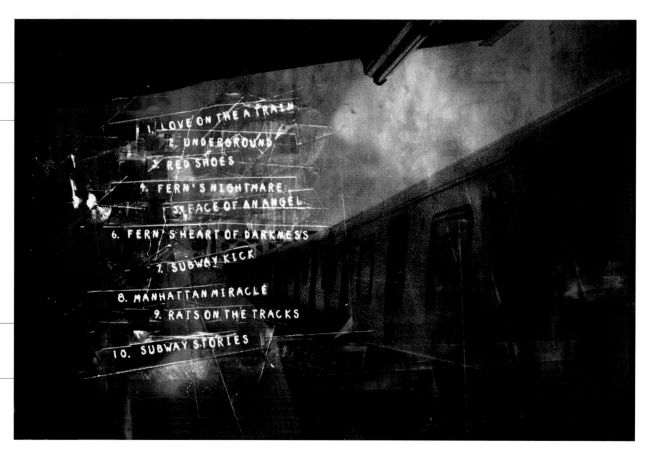

Mecca Bodega
Designer: Sean Mosher-Smith
Client: Hybrid Records/record company
Concept: "The grittiness of the subway and New York, where the band is from. The piece was originally done for the album Subway Stories."

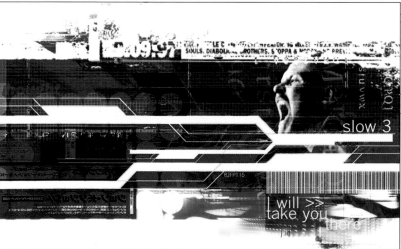

Persistence > Stability
Designers: Sean and Katie Mosher-Smith
Client: Self
Concept: Self-promotion

Junkster Single
Advertisement Art • Mr. Blue
Designer: Sean Mosher-Smith
Photographer: Steve Ackerman
Client: RCA Records/record company
Concept: "To promote the band's first single."

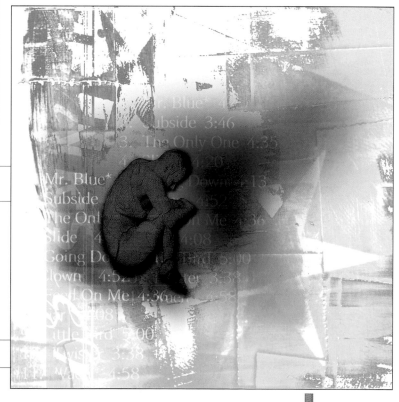

Ames Design, 5118 Greenlake Way North, Seattle, Washington 98103

The Apollo Program, 49 Greenwich Avenue, Suite 4, Greenwich, Connecticut 06830

Chris Ashworth, Still, still.media@virgin.net

Associates in Science, 443 Greenwich Street, 6th Floor, New York, New York 10013

Attik, 520 Broadway, 4th Floor, New York, New York 10012

Automatic, Top Floor, 100 De Beauvoir Road, London , N1 4EN, United Kingdom

Automatic Art and Design, 2318 N. High Street, #9, Columbus, Ohio 43202

BLK/MRKT inc., 705 12th Avenue, San Diego, California 92101

BOYZandGIRLS, 60 Avenue B, Suite 2D, New York, New York 10009

Brainstorm, Inc., 3357 Halifax, Dallas, Texas 75247

Peter Cho, Imaginary Forces, LLC, 6526 Sunset Boulevard, Hollywood, California 90028

Cranbrook Academy of Art, 39221 Woodward Avenue, P.O. Box 801
 Bloomfield Hills, Michigan 48303-0801

Cyclone Design, 1517 12th Avenue, Seattle, Washington 98122

The Designers Republic, 15 Paternoster Row, Sheffield, S12BX, United Kingdom

Spencer Drate, 160 Fifth Avenue, #905, New York, New York 10010

Faith, 26 Ann Street, Mississauga, Ontario, L5G 3G1, Canada

Graphic Havoc, 184 Kent Avenue, #311, Brooklyn, New York 11211

Manabu Inada, MTVi Group, 1515 Broadway, New York, New York 10036-5797

Viktor Koen, 310 East 23rd Street, Suite 10A, New York, New York 10004

Modern Dog, 7903 Greenwood Avenue North, Seattle, Washington 98103

PMcD Design, 484 Greenwich Street, New York, New York 10013

Popglory, 4555 Finley Avenue, Suite 16, Los Angeles, California 90027

Push, 18 Compton Terrace, London, N1 2UN, United Kingdom

Ride Studio, 331 Bush Street Southeast, Salem, Oregon 97302

Sagmeister Inc., 222 West 14th Street, 15A, New York, New York 10011

Jütka Salavetz, 517 W. 45th Street, Ste. 403, New York, New York 10036

Sayuri Studio, 24 Fifth Avenue, Suite 832, New York, New York 10011

Jason Schulte, 585 Howard, 2nd Floor, San Francisco, California 94105

Darren Scott, McCann-Erickson Manchester, Bonis Hall, Prestbury,
 Cheshire, SK10 4EF, United Kingdom

Segura Inc., 1110 North Milwaukee Avenue, Chicago, Illinois 60622

Slipstudios, 4421 North Francisco Avenue, Chicago, Illinois 60625

Slow Hearth Studio, 295 Sixth Avenue, #3, Brooklyn, New York 11215

Smay Vision, 160 5th Ave., Ste. 904, New York, NY 10010

P. 10–15 © Manabu Inada

P. 16–19 © Automatic

P. 20–21 © Thirst

P. 22–25 © Popglory

P. 26–27 © Brainstorm, Inc.

P. 28–33 © Modern Dog Design Co.

P. 34–35 © Peter Cho

P. 36–39 © The Designers Republic

P. 40–43 © Ames Design Co.

P. 44–45 © Zinzell

P. 50–53 © Stylorouge

P. 54–55 © Why Not Associates

P. 56–61 © Slipstudios

P. 62–63 © Sayuri Studio

P. 64–67 © Cyclone Design

P. 68–69 © Darren Scott

P. 70–73 © Attik

P. 74–75 © Cranbrook Academy/Jeff Miller

P. 76–81 © Spur

P. 82–83 © Jason Schulte

P. 84–85 © Push

P. 86–89 © Sagmeister Inc.

P. 90–91 © BOYZandGIRLS

P. 92–97 © Toupee

P. 98–101 © Scott Clum/Ride Studio

P. 102–103 © The Apollo Program

P. 104–107 © Segura Inc.

P. 108–111 © BLK/MRKT inc.

P. 112–117 © Associates in Science

P. 118–121 © Graphic Havoc

P. 122–125 © PMcD Design, Ltd.

P. 126–127 © Automatic Art and Design

P. 128–129 © Alexei Tylevich

P. 130–131 © Alexei Tylevich/Design Office: George Yu, Jason King

P. 132–135 © Chris Ashworth/Still

P. 136–139 © Alexandros Maslatzides/Studio Pangaia

P. 140–145 © Viktor Koen

P. 146–147 © Smay Vision

P. 148–151 © Paul Sych/Faith

P. 152–157 © Slow Hearth Studio